Kawaii Appliqué QUILTS

FROM JAPAN

Kawaii Appliqué QUILTS
FROM JAPAN

HOW ONE COUNTRY'S LOVE OF
ALL THINGS TINY POWERS TODAY'S
MOST INTRICATE QUILTS

NAOMI ICHIKAWA 市川直美
TERESA DURYEA WONG

SCHIFFER
CRAFT
4880 Lower Valley Road • Atglen, PA 19310

Other Schiffer Craft Books on Related Subjects:

Japanese Contemporary Quilts and Quilters: The Story of an American Import, Teresa Duryea Wong, ISBN 978-0-7643-4874-7

Cotton & Indigo from Japan, Teresa Duryea Wong, ISBN 978-0-7643-5351-2

Art Quilts Unfolding: 50 Years of Innovation, Sandra Sider, ed.; Nancy Bavor, Lisa Ellis, Martha Sielman, SAQA (Studio Art Quilt Associates, Inc.), ISBN 978-0-7643-5626-1

Designed by Lori Malkin Ehrlich
Cover design by Lori Malkin Ehrlich
Front cover image: Akiko Yoshimizu. *Summer Girl* (detail). 2022. 40 × 20 in. (102 × 3 cm). *Photo by Ayako Hachisu.* Back cover images: (*top*) Reiko Kato. *Around the World* (detail). 2013. 47 in. (120 cm) dia. *Photo by Yukari Shirai.* (*left*) Megumi Mizuno. *The Story of the Kokeshi* (detail). 2019. 72 × 80 in. (183 × 204 cm). *Photo by Yukari Shirai.* (*bottom right*) Yoko Sekita. *Midnight on Girl's Day* (detail). 2014. 74 × 51 in. (188 × 130 cm). *Photo by Yukari Shirai.*
Type set in Loretta Display/Loretta/New Atten

ISBN: 978-0-7643-6925-4
ePub: 978-1-5073-0565-2
Printed in India

10 9 8 7 6 5 4 3 2 1

Published by Schiffer Craft
An imprint of Schiffer Publishing, Ltd.
4880 Lower Valley Road
Atglen, PA 19310
Phone: (610) 593-1777; Fax: (610) 593-2002
Email: Info@schifferbooks.com
Web: www.schifferbooks.com

For our complete selection of fine books on this and related subjects, please visit our website at www.schifferbooks.com. You may also write for a free catalog.

Schiffer Publishing's titles are available at special discounts for bulk purchases for sales promotions or premiums. Special editions, including personalized covers, corporate imprints, and excerpts, can be created in large quantities for special needs. For more information, contact the publisher.

We are always looking for people to write books on new and related subjects. If you have an idea for a book, please contact us at proposals@schifferbooks.com.

Everything small is cute.
—SHŌNAGON SEI, *THE PILLOW BOOK*
(ca. 1002 CE)

▲ Toshikata Mizuno. *Sanjūroku Kasen, Hina Asobi Bunkyū Koro Fujin* (Enjoying the Doll Festival: Women of the Bunkyū Era). 1861–1864. Woodblock print from the series *Thirty-Six Elegant Selections*. Published in 1893. *Wikimedia Commons*

An obscure law in the 1600s set an entire country on a course to appreciate and adore tiny things.

▲ Keishū Takeuchi. *Hina Doll.* Illustration from *Bungei Kurabu*, vol. 18, no. 4. Woodblock print. Published in 1912. *Wikimedia Commons*

Kawaii is a sensibility that Japanese people have inherited from their ancestors.

▲ Top: Katsushika Hokusai. *Tama River in Musashi Province (Bushū Tamagawa)*, from the series *Thirty-Six Views of Mount Fuji (Fugaku sanjūrokkei)*. Circa 1830–1832. Woodblock print. 9⅞ × 14⅞ in. (25.1 × 37.8 cm). *Courtesy of the Metropolitan Museum of Art, Henry L. Phillips Collection, Bequest of Henry L. Phillips, 1939*

▲ Above: Antique *hina* dolls and hanging mobiles on display at the cultural center in Inatori, Izu Prefecture. *Photo by Teresa Duryea Wong*

▲ Once a year during the Hina Matsuri festival, elaborate *hina* dolls look out toward the Pacific Ocean from their hilly perch in the small town of Inatori, on the Izu Peninsula. *Photo by Teresa Duryea Wong*

▶ Inatori, Izu Prefecture, hosts the longest, outdoor stairstep display of traditional *hina* dolls in the country on 118 stone steps leading to the local shrine. *Photo by Teresa Duryea Wong*

Kawaii . . . is a certain type of non-threatening, youthful cuteness—think smiling cartoon characters—that has become popular all over Japan with everyone from the teen girls who started the phenomenon to big business.

—SUMIKO KAJIYAMA, *COOL JAPAN*, 2013

Acknowledgments

We are grateful to so many people who shared their time and talent in support of this book. Our hardworking photographers made these quilts look so beautiful: Ayako Hachisu, Yuko Fukui, Yukari Shirai, and Kimiko Kaburaki. Noriko Kimura provided the darling illustrations throughout the book, as well as the map of Hina Matsuri celebrations. Noriko Tamesue provided the graphic design for the pattern pages. Noriko Tonouchi and Ayu Ohta provided translation support. We want to express our appreciation to the *Quilt Diary* staff Motoko Kitsukawa, Kyoko Kikuchi, and Asako Kishimoto. Of course, the six quilters featured here spent considerable time with us and graciously shared their stories. We are especially grateful to them. In addition, we want to thank their husbands for their help in supporting us as well with transportation, logistics, and a myriad of other small things that were so helpful.

Editor's note: Japanese names are presented in this book in a Western format, with given name first, surname second.

Contents

◀ Yoko Sekita. *Midnight on Girl's Day.* 2014. 74 × 51 in.
(188 × 130 cm). *Photo by Yukari Shirai*

Part One
The Magical World of Kawaii

There is a culture of cuteness in Japan that is so pervasive it has its own name, *kawaii*. And the artists who live and breathe this iconic Japanese concept have created an entirely new genre of quilting: *kawaii* appliqué.

◀ Mini quilt by Aki Sakai, *Happy Time*.
Photo by Ayako Hachisu

Foreigners visiting Japan sometimes find it odd that the word *kawaii* is so popular in everyday conversation. In the mid-twentieth century, the term was used as a descriptor for something sweet and adorable, like a baby, or the youthful beauty and fashions of little girls or teenagers. But now, the pop culture uses for kawaii have expanded exponentially, and almost anything can be kawaii, including animation figurines, *gatcha* (toy capsules from vending machines), *netsuke* (small ornaments worn on kimonos or hanging from phones or backpacks), bonsai trees, miniature Zen gardens, *Pokémon*, the list goes on and on. Even sweetly decorated desserts, or the darling appliqué on a quilt, are kawaii.

By the time the 1970s rolled around, the definition also included an otherwise inexplicable fondness for fictional characters and their representations of wholesomeness and positivity. Hello Kitty, for example, first appeared in 1975. With her overly round face, adorable red bow, and no mouth, she is the epitome of kawaii. Today Hello Kitty is everywhere.

Now, well into the twenty-first century, the term is even used to describe things that are nice, or something that catches your eye, or it can be applied to an emotion or a feeling such as a something that is super cool, or nostalgic, even heartwarming. It's very difficult to explain to non-Japanese because the term covers a broad, and sometimes vague, area of sensibility, but for Japanese, *kawaii* is a useful word that transcends its historical definition.

All the quilters featured in this book feel a close association to the idea of kawaii. They agree that kawaii is an appropriate description of their style of quiltmaking that is executed with small, precious patches of appliqué. These six women were teenagers, or young adults, during the 1960–80 time frame when it was teenage girls in fact who popularized a loopy, circular style of cutesy handwriting that eventually helped push kawaii into mainstream culture. They have grown up with kawaii, and today, they feel that the definition of this term is flexible enough to encompass their own unique style of quilts.

◀ Tiny, handmade decorated balls form a flower in a quilt made by Megumi Mizuno. *Photo by Teresa Duryea Wong*

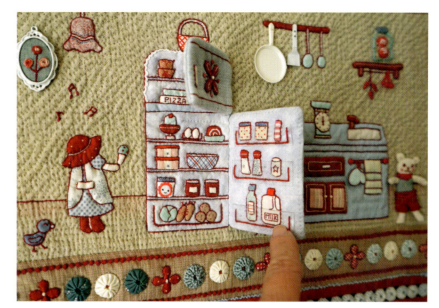

▶ Aki Sakai's exquisite quilts are full of surprises, including an appliqué refrigerator with a door that opens to see inside. *Photo by Teresa Duryea Wong*

▶ Reiko Kato returns again and again to her beloved Sunbonnet Sue. *Photo by Teresa Duryea Wong*

▶ Antique *hina* dolls on view at *Hyakudan Kaidan* (The Hundred Stairs) at the Hotel Gajoen Tokyo, a Tokyo Metropolitan Government designated Tangible Cultural Property. *Photo by Teresa Duryea Wong, with permission from Hotel Gajoen*

The View from Here

BY NAOMI ICHIKAWA

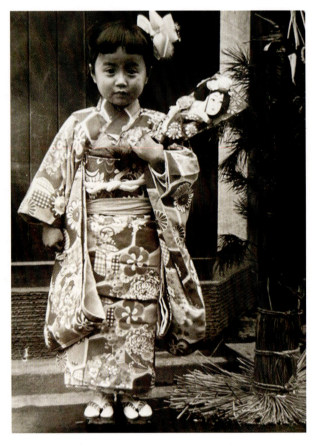

▲ Naomi Ichikawa as a young child in Japan in the late 1960s during the New Year celebration. Naomi's mother dressed her in her finest kimono and took a photo next to the *kadomatsu* (New Year's decorative pine tree). This was a typical kawaii look for girls at that time.

Step into a typical Japanese home and the first thing you're likely to see is a shoe rack alongside a sundry collection of tiny folk crafts, ornaments, or dolls. People everywhere enjoy tiny, crafted things, but in Japan the love affair with kawaii runs deep. It is a sensibility we Japanese have inherited from our ancestors, and it's especially visible in the homes of older generations, where miniature items including seasonal decorations, *kokeshi* dolls, bamboo baskets, mother-of-pearl boxes, and sculptures are artfully displayed throughout the home.

The origin of our love for cute things can be traced back 1,000 years. Most famously, there is a line from a classic piece of Japanese literature, where the modern translation is "everything small is cute," and most everyone is familiar with both this phrase and the unusual book where this sentiment comes from. *The Pillow Book* was written by Shōnagon Sei in the Heian period (794–1185 CE) during the time she spent at the Imperial Court. She wrote the book over many years, and it was completed in approximately 1002 CE.

This beloved book is hard to describe, but it is an eclectic collection of poetry, essays, musings, lists, and everyday observations, almost like a modern-day blog or an artsy Instagram account. In *The Pillow Book*, Sei uses the term *utsukushiki* (which loosely translates as *beautiful*), and over time this term, and Sei's entire sensibility, has become

Hokkei Totoya. *Poetess Sei Shōnagon, author of The Pillow Book.* Woodcut print. 1840. 8⅜ × 7¹⁄₁₆ in. (21.3 × 18 cm). The New York Public Library Digital Collections: Miriam and Ira D. Wallach Division of Art, Prints and Photographs: Print Collection.

synonymous with kawaii. In one chapter, Sei has written one small and endearing observation from each day, and one of these writings is the source for her most famous lines, translated here by Meredith McKinney:

Utsukushiki Mono
(Endearingly lovely things)

A baby's face painted on a gourd.
A sparrow coming fluttering down to the nest when her babies are cheeping for her.

A little child of two or three is crawling rapidly along when his keen eye suddenly notices some tiny worthless thing lying nearby.
He picks it up in his pretty little fingers, and shows it to the adults.
This is very endearing to see.
It's also endearing when a child with shoulder length "nun's cut" hairstyle that's falling into her eyes doesn't brush it away but instead tilts her head to tip it aside as she examines something . . .
All these are endearing.

Miniature Culture Flourishes in the Edo Period

While the idea of kawaii was first introduced in the tenth century, it was actually the Edo period (1603–1867) when miniature things began to boom, primarily due to a strange set of laws governing society during this time.

For 265 years, while Japan was closed to outsiders, the Tokugawa Shogunate ruled the country, and they were intent on maintaining the strict class structure of society: nobility, samurai, merchants, farmers, artisans, civil servants, and peasants. While it is true that the country was politically stable during this time, the edicts governing the everyday life of commoners were often harsh—but out of these challenges came ingenious work-arounds, and the remnants of those clever solutions remain to this day.

◀ Utagawa Hiroshige, *Ootenmachou Momenten* (Cotton Shop in Edo period), from the series *One Hundred Famous Views of Edo*. Woodblock print. 1858. *NDL Digital Collections, National Diet Library in Japan*

▼ *Below, left*: Utagawa Hiroshige, *Suruga-chō (Suruga tefu)*, from the series *One Hundred Famous Views of Edo*. Woodblock print. 1856. *NDL Digital Collections, National Diet Library in Japan*

▼ *Below, right*: Utagawa Hiroshige, *View of Nihonbashi Tōri 1-chōme* from the series *One Hundred Famous Views of Edo*. Woodblock print. 1858. *NDL Digital Collections, National Diet Library in Japan.*

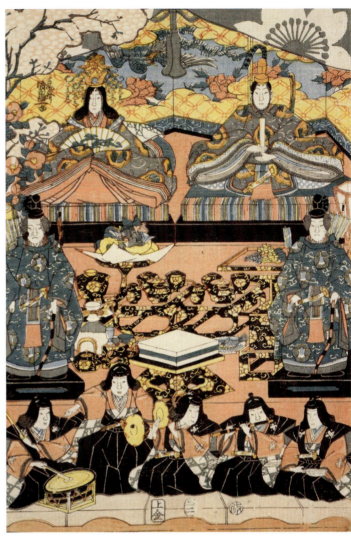

◀ Utagawa Yoshitora, *Shin-pan Katte Dogu Zukushi* (Kitchen Utensils in Edo Era). Woodblock print. 1857. *NDL Digital Collections, National Diet Library in Japan*

▲ *Above, left*: Ittosai Yoshitsuna, *Shin-pan Hako Niwa Zukushi* (Miniature Gardens in Edo Era). Woodblock print. 1853. *NDL Digital Collections, National Diet Library in Japan*

▲ *Above, right*: Ichiryusai Kunimori, *Hina Dolls*. Woodblock print. 1857. *NDL Digital Collections, National Diet Library in Japan*

Let me explain this part of our history. As the wars ceased and the lower classes of society such as merchants, farmers, and artisans found stability, they also began to acquire wealth, especially the merchant class. They began to show off their wealth by wearing luxurious silk kimonos, and they rebuilt or decorated their homes to showcase their status. In some cases, this newfound wealth led to a rapid decay in moral standards, and all of this enraged the ruling class. So, in order to stop these displays of wealth and extravagance in the lower classes, and to restore morality, the Tokugawa Shogunate issued a series of sumptuary laws, or luxury prohibition orders.

While many countries around the world once used sumptuary laws to control society, the swiftness and minutia of the sumptuary edicts during Japan's Edo period are unprecedented. One of the most famous sumptuary laws was the ban prohibiting the

lower classes from wearing silk kimonos. The new law declared that lower classes were allowed to wear only cotton or linen, and the only colors allowed were indigo, gray, or brown. And here is where one of the clever work-arounds influenced the entire Japanese textile culture to this day.

Out of necessity, the art of dyeing cotton and linen flourished and matured. New techniques were constantly evolving, and over time the common townspeople found ways to make this ordinary cotton and linen fashionable. They experimented with subtle changes in the dark hues and began incorporating designs within the patterns, and this led to the phrase "48 browns, 100 grays."

A new obsession with interesting and subtle color combinations was born, and mischievous uses of secret colors and patterns on the lining of cotton/linen kimonos also took hold. Taking advantage of adversity, Edo people acquired a sense of *iki* (chic) fashion.

Interestingly, it was this same idea of "48 browns, 100 grays" that also become a dominant color palette in Japanese quilts beginning in the 1990s. Recognizing this significant trend, I was the first person to coin this color preference the "taupe" palette in an article I wrote for *Patchwork Tsushin* in 2003 (no. 115). I was the editor at the time, and once my term was in print, taupe became the go-to word around the world to describe this genre of Japanese quilts.

But back in the Edo era, another sumptuary law had a lasting impact on Japan, and later our quilt aesthetic. Laws issued by ruling shogunate Sadanobu Matsudaira forced size restrictions on the construction of toys and *hina* dolls. (*Hina* translates as "specialized dolls.") Again, this edict had the same reasoning: it was meant to eliminate the desire to purchase the largest and most extravagant dolls and toys as a way to show off one's wealth and status.

This was especially meaningful to the construction of *hina* dolls, which were an integral part of the Hina Matsuri celebration (one of our five seasonal festivals). As a result, artisans and merchants were prohibited from making or selling toys or dolls larger than about 8 inches, or 24 centimeters.

Instead of being able to freely create large and beautiful *hina* dolls, the makers eventually began turning their artistry to working in miniature. They discovered ways to craft tiny, gorgeous clothing and detailed bodies with attractive facial expressions. In addition, these artisans began constructing an entire miniature world of trees, furniture, lanterns, and sweets to accompany the doll display. Entire chests of drawers, sewing boxes, tea sets, meal trays, household tools—all of these were created in a tiny scale with minute attention to detail. Even the family's crest could be included in miniature with the finest lacquer and gold leaf techniques.

As they honed the skills of working small, some makers began testing the limits of tiny by going even smaller. Crafts people began creating *hina* dolls that were so tiny that they came to be known as the "poppy seed dolls." They were highly prized at the time, and they are still coveted to this day.

Specialty stores began selling *hina* dolls and other miniature toys, and these popular stores lined the streets of Edo town, what is now Tokyo. These miniature crafts were considered "more than toys, but less than works of art," and they became a prominent part of the Edo era's sophistication, known as "Edo taste." While the fascination for these Edo tastes began with our ancestors, it has carried through to today. For foreigners, it might feel like the Edo era was long ago, but for many people in Japan, our great-grandparents lived during the end of this period, and so to us, it doesn't feel so long ago.

Japanese Girls Grow Up Surrounded by Small and Cute Things

Japanese people, especially girls, grow up surrounded by small and cute things. The best example of this is the Hina Matsuri, the monthlong celebration that culminates around March 3. Hina Matsuri, which is also known as the Doll's Festival, has been a fixture in the lives of common people since the Edo period.

Tradition dictates how the *hina* dolls are displayed. They are placed in a very particular order, on top of a red carpet, and decorations of peach blossom branches, tea sets, and other objects, as well as foods such as *chirashi* sushi and *sakura* mochi sweets, sit alongside the dolls. Beginning with their very first Hina Matsuri festival, young girls are asked to pray for lifelong health and happiness. Every year, they are inundated with cute gifts and the colors red and pink. As the girls grow up, parents and grandparents purchase more *hina* dolls to add to the annual celebrations, and the *hinadan* (*hina* doll display) grows and becomes more and more lively, and this continues until the girl gets married.

Department stores, bakeries, and sweet shops also contribute to the festivities with endless displays of tiny, precious sweets in pink, red, white, and lime green. Looking back, many adult women have fond memories of sitting at tables decorated with peach branches, eating doll sweets, and doing all sorts of cute things around the March 3 celebration.

Clearly, Hina Matsuri is the foundation from which a love of kawaii arose, myself included. I have so many precious memories that I carry with me to this day. As a young girl, I looked forward to my mother making sushi in the shape of dolls and celebrating by wearing a kimono.

When I was a child, everyone was obsessed with small, cute miniatures. Candies and sweets were often sold with bonus toys, or picture cards. The most famous of these is the Glico caramel. The chewy caramel cubes were first introduced in 1922 and came packaged inside a red box that is now an iconic symbol of the era. The red box features a marathon runner with his arms raised in victory.

Beginning in 1957, Glico began offering a special bonus inside each box—a tiny surprise plastic toy. The toys were dolls or furniture, such as chairs and tables, and even household goods like vacuum cleaners. Part of the joy was in the surprise, and part was in the miniatureness of the object. Children all over Japan became obsessed and began seeking out the Glico caramels and collecting the toys. When I was

▲ Vintage plastic toys available inside boxes of Glico Caramel. From the author's collection. *Photo by Naomi Ichikawa*

in elementary school in the late 1960s, the little bonus toys were all the rage.

Over the years, Glico added more variety to the toys they offered, and each tiny toy was so elaborately constructed that it looked remarkably like the real thing. Even to this day, we find them amazing, especially the adults who were coming of age in the 1960s and '70s. If asked, we are sure to share happy memories of playing with these toys and trading them with our friends.

The rise of popularity of the Glico caramels happened to coincide with Japan's period of high economic growth (1955–73), and during this very same time, a doll boom was born. The success of American Barbie dolls inspired a similar trend in Japanese-made dolls. However, the dolls made in Japan did not mimic the grown-up, shapely figures of Barbie; rather, they were cuter and with softer features, less mature. Girls loved them. The new styles lined the shelves of toy stores and department stores across the country, and, of course, lots of accessories were also available, such as outfits, purses, and shoes.

The next big cultural wave for girls was the plethora of manga (Japanese comic books) featuring female characters. This new wave of kawaii literature in the 1970s and '80s, with elaborate stories and expertly drawn characters that were cute and sparkly, captured the hearts of girls and young women across the country.

My generation (born between the late 1950s and late 1960s) was the one whose sensibilities were influenced the most by the wide variety of kawaii that swept the country, and many women from this generation went on to become today's Japanese quilters.

▶ Naomi Ichikawa measures the tiny appliqué figures in this quilt by Yoko Sekita. *Photo by Teresa Duryea Wong*

▶ ▶ Akiko Yoshimizu. *Summer Girl* (detail). 2022. 40 × 20 in. (102 × 53 cm) *Photo by Ayako Hachisu*

Japan's Unique Quilt Style: The Tiny Power of Kawaii Quilts

Now, I can finally get to the topic of quilts. I've seen a lot of Japanese quilts over my long career in the quilt industry, but in recent years there has been a series of quilts that have truly caught my eye. What they have in common is that they are highly detailed appliqué quilts, with sometimes thousands of small images such as houses, animals, people, and dolls. Many of the tiny kawaii characters sewn into these story quilts are having fun together. Their bodies, and the worlds they inhabit, are so detailed that they are dizzying. Every part of the quilt, right down to the borders, is so elaborately crafted that literally every inch is captivating.

Unlike art quilts and modern quilts, which are sometimes best viewed from a distance, these kawaii quilts invite you to look closely at every nook and cranny and enjoy discovering them up close. These quilts are joyful, sometimes cute, and they are rich in storytelling. When I study and take the time to appreciate all the elaborate miniature people and things, I can't help but feel the combination of the *The Pillow Book* sentiment that "everything small is

cute" mixed right alongside our Edo-developed tastes for endearing items.

There is no doubt that the kawaii quilt style was born out of these unique sensibilities that the

Japanese people have cultivated and cherished for centuries. It is my hope that this book will provide quilt lovers around the world with a richer understanding of these feelings and that you will cherish these quilts as much as Teresa and I do.

 Yoko Sekita. *Nohara 5-Chome 3*. 2007. 75 × 61 in. (190 × 157 cm). *Photo by Ayako Hachisu*

Understanding Hina Matsuri

March 3 is the traditional Girl's Day holiday, which coincides with the month-long celebration of Hina Matsuri festivals and displays of *hina* dolls. Hina Matsuri is one of the five historic *sekku* (festivals) held on what are believed to be sacred days: the first day of the first month, the third day of the third month, the fifth day of the fifth month, the seventh day of the seventh month, and the ninth day of the ninth month. However, to make things more confusing, some parts of the country commemorate Girl's Day and Hina Matsuri according to the lunar calendar, which would be April 3.

Families will typically display their *hina* dolls in the home for about four or five weeks before March 3, much the same way Christmas decorations are displayed for a month or more in Western homes. And it's not just homes. Temples, towns, businesses, hotels, and storefronts also display *hina* dolls during Hina Matsuri. The type of dolls on display, and how

▶ *Right, top: Tsurushi kazari* (hanging ornament mobiles) at Hotel Gajoen Tokyo, home of the Cultural Property *Hyakudan Kaidan* (The Hundred Stairs). *Photo by Teresa Duryea Wong, with permission from Hotel Gajoen*

▶ *Right: Hina* doll display inside a home in Inatori, Izu Peninsula. *Photo by Teresa Duryea Wong*

There is no end to the creativity of these handmade hanging ornaments, which are constructed using old silk kimono fabric. *Photo by Teresa Duryea Wong*

they are arranged, is quite specific. They are displayed on a red carpet, in cascading order with royalty on the top, on outdoor steps, or shelving built specially for these displays.

In addition to the *hina* dolls, homes, museums, and businesses and storefronts also display hanging ornaments along with the dolls during the festival. These handmade ornaments are typically small stuffed items such as balls, rabbits, hearts, triangles, and even shrimp and fish, and are often created from old kimono fabric. The ornaments are attached to long strings, with a dozen or more objects on one strand, and hung from the ceiling. The result is a rich, colorful sensation with striking, sedate dolls alongside whimsical characters swaying right in front of the viewer's eyes.

The quilters featured here all have vivid memories of growing up with *hina* dolls and Hina Matsuri celebrations. And like the rest of Japan, their attachment to these tiny dolls is lasting and strong. Many of them have family heirlooms of *hina* dolls that have been passed down for generations. It is difficult to overestimate how this fondness for miniature, kawaii things translates into a powerful motivation for these six quilters to make quilts with tiny appliqué.

Chasing Hina Matsuri: A Traveler's Perspective

BY TERESA DURYEA WONG

I was standing alone in the street (which was blocked to traffic) in the small town of Makabe, in Ibaraki Prefecture, on a very cold morning, when a local woman walked up to me and asked me in English where I was from. I replied, "Texas," then she hugged me and thanked me for traveling so far. That encounter pretty much sums up the incredible warmth everyone in this small, historic village shares with its visitors.

The day I spent there was the national Girl's Day holiday, and the woman who hugged me was part of a group of community volunteers who welcome the thousands of visitors who descend on this remarkable place for the Hina Matsuri festival. The vast majority of visitors are from Japan. Foreign tourists do come, but only the intrepid ones are willing to make the long trek. Makabe is not easy to get to, but it's a place that's so charming once you step foot on the ancient streets and see the beautiful wooden homes and buildings, it's difficult to muster the desire to leave.

In the early years of the 2000s, Makabe and two other small towns merged to become the city of Sakuragawa. Even though Makabe has been incorporated into a larger city, the old buildings in the center of town remain as they would have looked 400 years ago. In fact, 104 buildings clustered along the streets are registered Tangible Cultural Properties, an incredible number even by Japanese standards.

Each year, the entire community comes together to host a vibrant and memorable Hina Matsuri festival. For a full month from early February through March 3, storefronts and homes display *hina* dolls and hanging ornaments, and visitors are free to wander in and look, even inside the homes. The nineteenth-century Iseya Ryokan (hotel) offers a traditional lunch that is available only during this special celebration, and all along the streets outside, locals offer free drinks and treats to visitors.

▲ Most everyone participates in the walk from the temple through the historic town to the river as part of the Girl's Day celebration. On the left are some of the town's 400-year-old wooden buildings. *Photo by Teresa Duryea Wong*

▲ Shinto *kannushi* (priests) lead the children in a parade through Makabe to the river, where small boats are set afloat during the Girl's Day ceremony. *Photos by Teresa Duryea Wong*

◄ *Left:* Children and volunteers make these small boats from bamboo. They are decorated with paper figures representative of *hina* dolls and set afloat during the ceremony. *Photo by Teresa Duryea Wong*

▼ *Bottom:* Makabe's nineteenth-century Iseya Ryokan (hotel) offers a traditional lunch during this special celebration. *Photo by Teresa Duryea Wong*

▶ Dazzling display of hanging ornaments inside a Makabe store. *Photo by Teresa Duryea Wong*

But the best part comes on the actual day—the third day of the third month—where local children participate in a ceremony led by a Shinto *kannushi* (priest). Even though the holiday is Girl's Day, this is a celebration about family, and everyone, even boys, takes part. After the children receive their blessings, local volunteers hand out small handmade boats crafted from bamboo, with two tiny paper figures representing *hina* dolls inside the boat. Next, the children, their parents, and seemingly the whole town form a parade behind the *kannushi* through the streets to the river, where the children set their boats afloat in the water, in a ceremony known as *nagashi-bina* (floating paper dolls downriver).

The centuries-old practice of floating small boats with paper *hina* dolls can be traced back to several different Chinese and Japanese traditions. Some beliefs hark back to a time when girls were expected to metaphorically cast away their impurities. Others believe the practice is a way to ward off evil spirits. A third belief is that the practice dates back to a banquet by a winding stream on the *shinichi* (day of seasonal change), when poets in ancient times would float cups of wine down the stream.

These days, seeing hundreds of tiny boats floating downstream along the melting ice in the small village of Makabe is a heartwarming moment of unity for these children, their parents, and each visitor. As a *gaijin* (foreigner), it was wonderful to be part of a ritual that celebrates youth, welcomes a new season, and creates hope for the future.

Much farther south, the tiny town of Inatori sits on the Izu Peninsula, a rocky territory that juts out into the deep-blue waters of the Pacific Ocean. The region is known for its luxury resorts featuring traditional outdoor *onsen* (baths) and priceless ocean views. But Inatori is also known for another tradition—a three-month celebration of Hina Matsuri.

From January through March, the 118 stone steps leading to the local shrine are lined with the most lavish, and longest, outdoor stairstep display of traditional *hina* dolls in the country. The dolls rise up the hillside so far that the ones at the top appear as just tiny bits of faraway color. The order and placement of each style of doll are determined by centuries of tradition.

Back in the center of town, the Inatori Cultural Park hosts a museum that is chock-full of *tsurushi kazari* (hanging ornament mobiles) and *hina* doll

▲ An exhibit of *hina* dolls and hanging mobiles inside the Inatori Cultural Park. *Photo by Teresa Duryea Wong*

displays. The place is so colorful and so charming that it's hard to decide where to focus. Strands and strands of festive, handmade stuffed fish, birds, bunnies, and flowers hang from the ceiling from every corner of this small gallery.

While the streets of Makabe and Inatori have small-town, relaxed vibes, the Hotel Gajoen Tokyo is the polar opposite. Founded almost a century ago in 1931 as the Meguro Gajoen, this historic hotel bills itself as the most magnificent place of art in the East. While parts of the complex have been restored, the Hyakudan Kaidan (100 stairs) are original and have been named a Tokyo Metropolitan Area Designated Tangible Cultural Property.

▲ ▲ ◀ One of the seven galleries inside the Holtel Gajoen Tokyo features an entire city of *hina* dolls. Another gallery is filled with cat *hina* dolls. The galleries are part of the Hyakudan Kaidan (the Hundred Stairs). *Photos by Teresa Duryea Wong, with permission from Hotel Gajoen*

▲ The Hotel Gajoen Tokyo commissioned the artist Touko to create a special display of *hina* dolls inside the Hyakudan Kaidan (the Hundred Stairs). Touko is a renowned doll maker living in Shiga Prefecture. These dolls are costumed in authentic attire from the Heian period (794–1158). The fabric is hemp, a specialty of the Shiga region. *Photo by Teresa Duryea Wong, with permission from Hotel Gajoen*

Along those hundred steps are seven lavishly decorated art galleries that host rotating art exhibits, including quilt exhibitions I have visited in years past. During Hina Matsuri, each room is filled with *hina* dolls and hanging ornaments reflecting a specific theme. The line to enter the show is long and winds through most of the hotel. After a very crowded elevator ride, visitors are instructed to remove their shoes to protect the historic steps and galleries. Plastic bags are provided, and visitors carry their shoes with them.

Even if these galleries were empty, the art and gorgeous designs that are part of the floor, walls, and ceilings would be enough to captivate visitors. But on top of that, each room is filled with charming *hina* doll displays. One gallery showcases antique dolls, while another gallery has taken up nearly the entire floor to display a busy city scene with every character imaginable, including royal *hina* dolls who overlook the merchants, peasants, soldiers, and children below them. Yet another room has brand-new *hina* dolls that have been created by a commissioned contemporary artist. Continuing on up the steps, one entire room is filled with glass cases displaying the fragile, famed poppy-seed *hina* dolls, which are no bigger than a fingernail. Yet another room has cat *hina* dolls. That's right, all the dolls are cats wearing elaborate costumes, which is so Japanese.

As a foreigner, attending so many diverse celebrations of Hina Matsuri all across the country has given me the priceless opportunity to see Japan up close, and to relish how people in different parts of the country come together with a shared goal to celebrate girls, family, and national culture.

Kawaii Quilts in the Home

As Naomi explained, many of today's Japanese quilters grew up celebrating Hina Matsuri, and for these six artists in particular, it is difficult to overestimate how their fondness for adorable, kawaii things has been transformed into a powerful motivation to make story quilts with tiny appliqué.

In order to hear their stories and see these incredible quilts up close, Naomi and I traveled across Japan to visit each quilter in her home. Just as Naomi wrote, inside the door of every home we were met with darling displays of *hina* dolls, or ornaments, even mini quilts, and small three-dimensional quilted houses. As each quilter unfolded stacks of quilts to show us—revealing decades of experience and dedication to their craft—it was a precious opportunity to better understand their creative lives.

None of the quilters featured in these pages use a sewing machine. Everyone is piecing by hand, making needle-turn appliqué, and, of course, finishing the quilt with hand quilting. The best estimate of quiltmaking techniques in Japan is that at least 80 percent of quilters work entirely by hand. This is the exact opposite of Western techniques, where the vast majority of quilters work by machine.

When asked about their experiences of learning to use modern sewing machines, we heard hilarious stories about the few times they did try to use a sewing machine, with disastrous, even painful, outcomes. Even more curious is the fact that some of these quilters are big award winners, some of Japan's most accomplished makers, and along with the first-place ribbons, they have been awarded sophisticated sewing machines as prizes. But those machines sit, often tucked far beneath a table or shelf, with their

▼ Yoko Sekita. *Wind God, Thunder God* (detail). 2020. People in Nagoya, as it looked in the 1960s, rendered in Sekita's signature humorous appliqué, as they run about during a storm. See full quilt on p. 78. *Photo by Yuko Fukui*

▲ Aki Sakai hung this showstopper temporarily in her home on the day we visited. It is a visual treat, filled with impeccable artistry and sweet family stories. The title is *Heartwarming Days,* and she made it in 2024. 57 × 57 in. (144 × 144 cm). *Photo by Teresa Duryea Wong*

dustcovers on, and never used. Each of these quilters has well-honed hand-working skills, and because of that, switching their brain to use a machine can be a daunting, perhaps even awful, experience.

While many quiltmakers in the Western world have a dedicated sewing space in their home, most Japanese quilters do not. Rather, they work wherever they want, at the kitchen table, in a tiny corner of the living area, in the garden, and it's easy to move about because there is no machine or fancy equipment to relocate, just your small bits of fabric and needle and thread. Japanese homes are typically small, and there is very little storage. So, these makers usually collect fabric only for the one quilt they are working on at the time. What's more, because they are working by hand, the process is vastly slower than machine work. Most of the quilts featured here took the artist between one to two years to make.

Another commonality of each of these quilters is the incredible tinyness of their creations. Just like the poppy-seed *hina* dolls, some of these makers have created appliqué figures that are no bigger than thumbprints. Seeing them up close raises the question of how the maker can see well enough to work in this miniature scale. The answer for almost all of them is to use high-tech magnifying glasses, the one fancy notion they can't do without, and good light.

Discovering Taupe and the "48 Browns, 100 Grays"

One of the things that first captivated me about Japanese quilts was the astonishing taupe palette that so many traditional quiltmakers adopt. History often reveals answers for us, the why and how a thing came to be. When we see farmers, peasants, and fishermen going about their daily lives in the famous *ukiyo-e* (woodblock prints) of Katsushika Hokusai, it is easy to just assume that the simple, dark clothing they wore was a preference, as if the jackets and loose pants made the work easier than an elaborate kimono. And perhaps that is partly true. But it was actually those odd sumptuary laws going back 300 and 400 years ago that forced commoners to wear cotton and linen, and eventually to become world-renowned dyers of indigo, browns, and grays.

As the "48 browns and 100 grays" evolved over the years, they became a preferred palette for quiltmaking. The earthy colors, combined with indigo, are the colors of the natural world, the sea, and the sky. These are the same colors seen in the pottery and teapots in Japanese homes and the dishes and cups used for meals. The tans, browns, grays, rusts, creams, mauves, and light greens of this palette are quiet colors. They do not scream. And in this way, they are the very essence of *iki*, which first took hold during the Edo era.

Iki is a Japanese word for which there is no one-word English translation. The closest translation is the French term *chic*, which means elegant taste. But *chic* does not fully express *iki*.

In 1926, the Japanese philosopher Shūzō Kuki was living in Paris, where he was inspired to write *The Structure of Iki* (Iki nō Kōzō) (1930), a seminal book considered by many to be a literary masterpiece. Shūzō's aim was to explain the essential Japanese

▼ Reiko Kato. *Hand in Hand* (detail). 2017. *Photo by Yukari Shirai*

concept of *iki* in terms a Western sensibility could understand. He is widely considered to be Japan's first cultural anthropologist, and nearly a century later his work still holds meaning. In the twenty-first century, his theories are relevant for helping quilters and art lovers around the world understand the allure of white, off-white, indigo, and the taupe, brown, and gray quilts of Japan. Their power comes softly, and thus, just like a precious whisper from the past, their magnetism is unforgettable. Learning to appreciate *iki* requires time.

Both Megumi Mizuno and Reiko Kato have dedicated themselves to working in the *iki* taupe palette. But while taupe is their go-to palette, both quilters also find creative ways to incorporate brighter colors. Also, right alongside these taupe enthusiasts, you will find that Yoko Sekita, Aki Sakia, Akiko Yoshimizu, and Hiroko Akita love to explore a full range of colors, but they do so in an extremely refined manner. Regardless of their palette, each of these accomplished artists has a story to tell, and by studying their quilts we are presented with a special opportunity to absorb the deep history and rich culture, and the complexities of kawaii, throughout the beautiful country of Japan.

◄ A beautiful antique silk kimono is a backdrop for these small *hina* dolls inside the Hotel Gajoen. The galleries are part of the Hyakudan Kaidan (the Hundred Stairs), designated as one of the Tokyo area's treasures, a Tangible Cultural Property. *Photos by Teresa Duryea Wong, with permission from Hotel Gajoen*

▲ Hina Matsuri display inside the Hotel Gajoen

Part Two
Kawaii Quilters

Meet six artists who embody the idea of kawaii with quilts that are so small they can fit in the palm of your hand, or large wall quilts that are created with tens of thousands of teeny patches of appliqué. In these quilts, the kawaii culture delivers powerful, sophisticated artworks that are distinctly Japanese.

Each quilter is introduced in a story written by Teresa Duryea Wong. Their quilts, and the hundreds of years of Japanese culture hidden among the tiny details, are expertly described by Naomi Ichikawa.

◀ Megumi Mizuno. *The Story of the Kokeshi.* 2019. 72 × 80 in. (183 × 204 cm). *Photo by Yukari Shirai*

Yoko Sekita
Let the Quilts Do All the Talking

In a country where art and craft are usually learned under a very strict and well-respected teaching system, Yoko Sekita is an outlier. She is a completely self-taught quiltmaker. But Yoko has one huge advantage: she was born an artist.

It took years before her artistic talent surfaced, but once it did, things happened quickly. As a child, she never seemed interested in drawing or making art, rather, she preferred reading and playing outside. She describes herself as a curious and unconventional child. In high school she took an art class, and it didn't take long before the teacher recognized her talent and recommended she attend an art school for college. Fortunately, she took his advice.

After college she went to work as a graphic designer, and at that job she was asked to sketch out a sample idea for a *manga* (Japanese comic) magazine. Displaying Yoko's innate talent, the sample captivated her peers. That small drawing led to a big career move as a writer and artist for a weekly series for the girl's manga magazine titled *Margaret*.

She joined *Margaret* in the mid-1970s when this genre of literature was booming. She was still in her early twenties at the time, but she and other female writer/artists were helping shape an entire generation of girls who for the first time were seeing in print female characters who were heroines and interesting individuals. These were stories about love and life, and young girls in the manga world played a role that far exceeded the typical housewife expectations of the generation before them.

▲ Yoko Sekita in her home in Saitama Prefecture. Behind her is her beloved garden where she often sits to make quilts, and spread on the table are many of her masterpiece quilts. *Photo by Ayako Hachisu*

Each edition of *Margaret* had several storylines created by different authors, similar to short stories, and today the surviving copies of the magazines from the 1970s and early '80s are highly coveted collectors' items. It would be fascinating to go back and study Yoko's drawings from those issues; however, she published under a pen name and has vowed she will never reveal that name to strangers.

Margaret became a poster child for all things kawaii. It was a powerful influence in shaping culture and changing language. Before *Margaret*, the term *kawaii* was reserved mostly for things that were cute and pretty. But with the power of the press, and a generation of teenagers who were experiencing freedom in a new era of economic growth, kawaii became a stronghold—a "go to" expression for capturing their fresh emotions.

With an intense study of Yoko Sekita's quilts, it becomes easy to make a direct connection between her style of endearing and timeless appliqué montages to her skill and experience as a manga artist. Like a comic sketch, her figures in cloth seem to be created with ease. They move and play about as effortlessly as the outline figures in the panes of a manga. And most of all, her montages tell a story.

To read these stories is a bit like reading a memoir of Japanese culture, or the pages of a diary. She creates stories purely from her imagination and her memory. There is no need to rely on photographs. The narratives are fresh in her mind and transferred directly to cloth.

Yoko and her husband live in the Kita-Urawa neighborhood of Saitama in Saitama Prefecture. Their neighborhood is filled with homes and gardens, with plenty of cherry and plum trees, and enough open space to enjoy the tidy yards. Yoko's kitchen and dining area look out over her large garden and patio area, and it is an inviting space. When the weather's warm, she often sits outside to sew.

Both she and her husband love to travel, and she is often inspired by her trips to create quilts based on memories from these faraway places. She has re-created entire scenes from village life in Germany and nightlife in Moulin Rouge in Paris, as well as the Egyptian monuments from the Metropolitan Museum of Art in New York. But while travel is a big part of her life, it is somewhat ironic that Yoko almost never ventures far from home while in Japan. She prefers to stay home, and she relies on her husband to keep her up to date on things. She calls him her "window to the world."

It was her husband, in fact, who helped me communicate with her when I first wrote about her quilts back in 2014. He was indeed my window to Yoko Sekita. We eventually did meet in person, but Yoko is not one who speaks easily about herself. She would rather let her quilts do all the talking.

Yoko was a painter for many years until she happened to see a quilt exhibition one day and was captivated. She thought that working with textiles would be an excellent outlet for her own ideas, and she went home and tried it out. She had no instruction, no books, and did not turn to YouTube or the internet for explanations. She just experimented and tried things until she settled on techniques that work for her. When you have the rare chance to see her quilts up close and to touch them, it becomes obvious that her sewing techniques are unconventional. The patchwork, appliqué, and bindings are constructed naively. But these methods only add to the artistry. They immediately send a signal that this is an artist whose expression is completely original. There are no influences from the quilt community, only pure talent to create entire worlds from her own imagination using her own methods.

On the day we visited, she brought out stacks of folded quilts for us to see. Unfolding each one was like reconnecting with an old friend. Her quilts have

been exhibited widely and published in numerous books and quilt magazines, and many of them are unforgettable. Their content is so diverse and the stories are so rich that it is impossible for me to choose just one favorite.

One of her darker, more dramatic quilts features huge, highly animated depictions of Raijin, the god of thunder, and Fūjin, the god of wind. And these beloved Japanese mythological figures overlook a scene straight out of Hollywood—the 1985 movie *Back to the Future*. Yoko is admittedly captivated by thunder and lightning. As a child, she would often run outside during storms to see what was happening, only to be dragged back inside by her mother. So, when she first saw the time-traveling movie that used lightning as source of power, she was inspired to make a work of art that combined all of these ideas—her own storm-filled memories, mythological Japanese gods, and a wildly popular movie from America. Doc and his DeLorean are featured, but the windswept characters are all locals who are struggling to hold on. Behind them is a street from Nagoya as it looked when Yoko grew up there. She even included herself in the picture as a young girl in the clasp of her mother's grip.

Another of my favorite quilts features a fictional scene where the Hina Matsuri festival is turned on its head. Here we see the usually sedate *hina* dolls come totally alive at night. Everyone is having a grand old time, and there is chaos amid the fun. The dancers and musicians are kicking their legs up and swaying to the music. The emperor and empress have been set free, and they appear right under the colorful *tsurushi kazari* (mobiles) with the traditional stuffed birds, fish, flowers, and other characters that dangle from the top.

Each quilt in Yoko Sekita's collection is filled to the max with imagery, memories, and history. To know them is to walk through Japanese culture, ancient traditions, and modern ways of life. Even the quilts that are based on her travels hold secret Japanese insights. In this way, this outlier of Japanese quilting is very much an independent artist who is expressing parts of a deeply personal world. She is indeed a treasure.

Awards

A Busy Wedding Day

Like all of Yoko Sekita's quilts, this one tells a very special story. It is the 1960s, and the family has gathered for a cousin's wedding. Autum is in full swing, and the leaves are at their most colorful. Yoko has lovingly captured the nostalgia of weddings from another era—ones that were held at home. In the center of all this bustling activity is the extended family who have gathered for the wedding, but they are too impatient to wait for the bride to finish dressing. They are drinking and laughing, the bride's father is drowning his sorrow, and children run around unchecked. Yoko's hometown of Nagoya was known for its lavish wedding celebrations, and seemingly the whole town would take part. In the foreground, we see neighbors bringing sweets and flowers, delivering barrels of sake, taking photos, even knocking over the camera's tripod.

The relatives are running because they are late. The woman is wearing a *tomesode* (short-sleeve kimono worn only by married women), and her husband is wearing a *hakama* (baggy garment worn under a kimono) and a black kimono on top with the family crest.

◀ Yoko Sekita. *A Busy Wedding Day*. 2009. 74 × 59 in. (188 × 150 cm). *Photo by Ayako Hachisu*

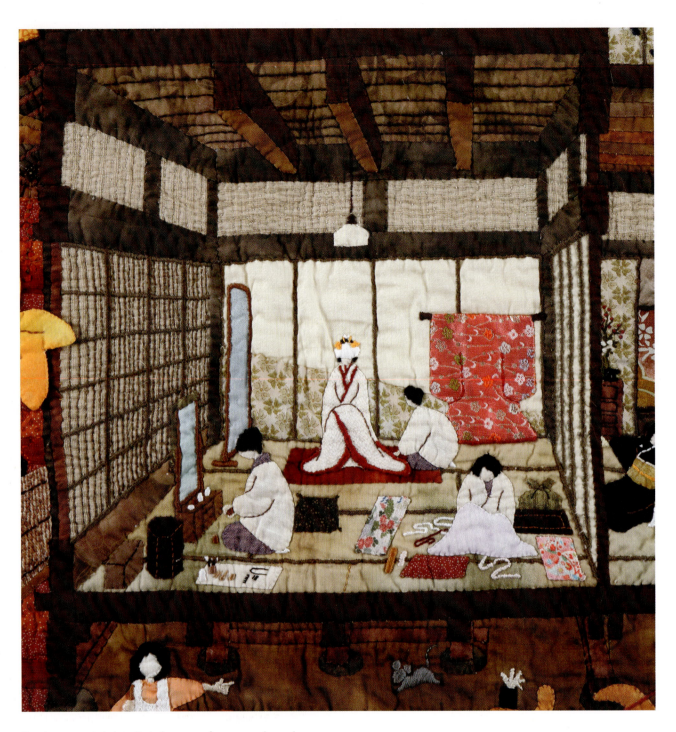

For her special day, hairdressers from nearby salons arrive in the morning to help the bride prepare her *bunkin takashimada* (elaborate wedding-day hairstyle of buns and knots). The hairdressers also help the bride get dressed in her *shiromuku* (traditional white kimono) with *uchikake* (bridal robe).

The father of the bride has had too much to drink. He's starting to feel lonely since his daughter will leave their home. The mother of the bride tries to keep her husband in check. A grandmother is peeking through a small gap in the *shoji* (sliding screen door). She asks, "What's going on out here?"

Right: Older relatives are already drunk, and they begin dancing, even though they had plenty of warnings from the bride's mother (who is seen off to the right side), but as is typical in families, they didn't listen. The elders are wearing black kimonos with a family crest, which was typical formal attire worn on special occasions. On a high shelf near the ceiling there is a *kamidana* (small Shinto altar shrine for homes; literally translates as god shelf).

Opposite: By eliminating the front elevation of the house, Yoko gives her viewers a glimpse of the whole world on this day—inside and outside the home. Neighbors are in a celebratory mood, ladies are chatting, and a student dressed in the sailor suit uniform slips and falls.

Below: The little girl trying to run away is Yoko herself. She hated wearing a kimono and tries to get out of it. This room is filled with nostalgia, including her school uniform hanging on the wall, the old-fashioned chest of drawers, and vintage wall clock. Far above in the upper attic, a family of mice is having a wedding of their own.

Friends of the Metropolitan Museum

New York City is Yoko Sekita's favorite place to visit. And once she's there, she can't wait to visit the Metropolitan Museum of Art, especially the ancient Egyptian exhibition. In some of murals there, Yoko was especially captivated by the way the human faces were depicted sideways. She loved these figures so much that she wanted to carry each of them back to Japan so she could make them into quilts. Instead, she relied on her memories to make this magnificent quilt. The king and queen are in the center, and servants surround them. She has incorporated many different Egyptian patterns and hieroglyphics. But this masterpiece is also filled with inside jokes and pranks, adding a bit of her manga style to this quilt.

Here's part of her inside joke. The hieroglyphs seen here have been translated to Japanese but written in an ancient Egyptian style. She's renamed the king Tagosaku, and the queen's name is Ine. What's more, both of these names were given to rural people, not royalty.

◄ Yoko Sekita. *Friends of the Metropolitan Museum.* 2010. 95 × 80 in. (240 × 203 cm). *Photo by Yukari Shirai*

Above: The servants here are bored, so instead of working, they are playing the Japanese game *acchi muite hoi* ("look that way"), which is a twist on the game rock, paper, scissors.

Below: Here, she has described the duties of the servants exactly as she saw them in the Met's exhibition.

This servant has forgotten about work and instead is enjoying a few sweets.

Midnight on Girl's Day

Yoko always thought *hina* dolls would be more fun if they could move, so she has created a world where the normally sedate dolls come alive at night. In fact, these dolls have quite a party; there is drinking and dancing, and the entire scene seems topsy-turvy. She has transformed these normally well-behaved dolls into a rowdy party, and in doing so she has made them look quite human. Each doll is properly dressed, and the props surrounding them are faithful to the traditional *hinadan* (*hina* doll display) arrangements. In addition, the swaying *tsurushi kazari* (mobiles) are eye-catching and the bunny, bird, fish, carrot, strawberry, and other objects are also true to tradition. The red carpet and the gold folding screen are decorated with hexagons.

At the bottom, a giant cat is pretending to sleep through the whole thing but keeps one eye open just to check. There is a surprise guest, a tiny girl wearing a kimono with her arms raised as if she wants to join the fun—that is Yoko herself. There is also a boy dressed in an elaborate red-and-black armor costume who is trying to enter the party, but a guard holds him back because he is not allowed. He belongs in the next holiday—Boy's Day.

The empress is sipping white sake on a *hinadan* (*hina* doll display).

◀ Yoko Sekita. *Midnight on Girl's Day*. 2014. 74 × 51 in. (188 × 130 cm). *Photo by Yukari Shirai*

Above: Here we see the characters running wild. There was a surprise attack, and the emperor (*upper right*) has fallen down. Alongside him is another character who is crashing to the floor. This character is known as the minister of the left. He has a long gray beard because he is the older of two bodyguards, or administrators, for the emperor. (The minister of the right is always younger.) In between them are two vases filled with peach blossoms that are sitting on a *sanbō* (small stand with a base that has decorative cutouts on three sides). The *sanbō* can be used in Shinto rituals, or to present objects to nobility.

Left: There is no end to the tiny details that make this quilt so extraordinary. Here we see traditional household items used in the palace: two hibachis made with black cloth (which conveys that they are usually lacquered), plus on the shelf behind them are tea utensils and a sewing box.

Opposite, bottom: Precious detail went into making these *tsurushi kazari* (mobile) objects.

One of the three court ladies jumps on top of a *tansu* (chest of drawers) and dances while waving a fan, just like a disco queen from the 1980s. Her dance music is performed by a *gonin bayaashi*, which is traditionally a set of five male musicians. During the years when Japanese people were excited by the bubble economy, young girls would go to discos and dance on *otachidai* (stands or stages), and this was really popular at the time. This dancing doll reflects that social phenomenon.

Nohara 5-Chome 3

When Yoko Sekita grew tired of the weeds that kept popping up in her garden no matter how hard she tried to prevent them, she suddenly had an idea. *What if there were a person the size of my thumb who lived here in the garden?* A wave of happiness came over her, and she immediately stopped weeding and started making a quilt based on this fantasy. The entire surface of the quilt is colored as if it is a deep red-orange sunset in the height of the beautiful autumn season. Leaves, vines, and weeds cover everything. Tiny people peek out here and there.

The quilt title comes from her address. Her house is actually 5-Chome 2, so she named her garden 5-Chome 3.

So many classic stories are depicted in every inch of this quilt, ranging from characters from the French fairy tale *The Blue Bird* to Snow White and the witch. And we see a young girl painting and other characters from Yoko's imagination.

◀ Yoko Sekita. *Nohara 5-Chome 3*. 2007. 75 × 61 in. (190 × 157 cm). *Photos by Ayako Hachisu*

Open Sesame

This quilt tells the story of *One Thousand and One Nights*, and the shape is long and narrow, just like a magic carpet. She has titled this one *Open Sesame*, which is a story that was added to *One Thousand and One Nights* by a French translator, and it happens to be one of Yoko's favorite stories. She was inspired to make this quilt back in 2006, after hearing news of violence and repeated conflicts in Arab countries. Her wish is that somehow, the words *Open Sesame* could bring world peace.

The most famous storyteller of all, Scheherazade, is being carried to the royal palace for her night with the king.

Yoko Sekita. *Open Sesame*. 2006. 79 × 45 in. (200 × 115 cm). *Photo by Ayako Hachisu*

Above: The royal palace is illuminated by the light of the crescent moon. Yoko has re-created this scene purely from her memories of reading these stories as a child.

Right: At the top of this detail we see the servants carrying a variety of objects, while the thieves lurk below.

Travel Advice—Germany

As is typical of her quilts, Yoko loves to intersperse characters from fairy tales right alongside ones from television and movies, or even sometimes real people. For this quilt, she's placed her characters among a charming village in Germany that she once visited during a vacation. Here again, every inch is covered with detail and there is so much to see and study. Even though the setting is very German, the overall vibe looks like it could have been part of a Japanese manga.

▲ Yoko Sekita. *Travel Advice—Germany*. 2019. 65 × 76 in. (166 × 194 cm). *Photo by Yuko Fukui*

Typical German characters and people fill this scene. There is a zeppelin alongside characters from the *Pied Piper of Hamelin* and the *Town Musicians of Bremen*. Beethoven and Einstein make an appearance. Even the famed nineteenth-century Japanese writer Mori Ogai is there. A pink German Volkswagen Beetle sits in the town square next to ancient German buildings. There is so much nostalgia and inside stories captured here that it is somewhat dizzying.

Characters dressed in medieval German costume guard the palace while
children are climbing Rapunzel's tower by holding on to her long hair.

Above: There is an explosion of humor in this scene. We see the top of Beethoven's head as he is leaning over two children who have left their piano practice. Sheet music flutters to the floor, including *Fűr Elise*, one of Beethoven's most famous songs often performed by children. And the piano students have tied up Bach, who is Beethoven's sworn enemy. Einstein is conducting experiments next door. In the upper right, there is a *maneki-neko* (lucky cat) alongside a normal cat.

Snow White holds an apple while following the witch, who is pulling an apple cart. The seven dwarfs are, of course, close by. At the bottom of the scene, a couple is dancing while listening to the Victrola.

Travel Advice—Prologue

This quilt is the first in a series of travel-related themes. In this one, she has depicted a free-flowing journey that transcends time and place. The train that carries us on this journey is the Galaxy Railway, which departs from Tokyo Station, the gateway to Japan, at midnight. On the platform we see many different characters from familiar stories and television dramas. They are all waiting to depart. Both the brightness and darkness of the sky are beautifully executed. At the bottom of the quilt, Yoko had re-created what her desk looked like while she was away with all kinds of tiny people creating mischief.

Charlie Chaplin, Sherlock Holmes, Mary Poppins, Harry Potter and his friends, even Little Red Riding Hood and Anne of Green Gables are all gathered here waiting for the mythical train. Other characters from modern animated films and television are also depicted. High school boys and girls wearing their school uniforms are lined up, but one student is trying to get away, and that of course is Yoko herself.

◀ Yoko Sekita. *Travel Advice—Prologue.* 2012. 80 × 68 in. (203 × 173 cm). *Photo by Ayako Hachisu*

Opposite: The quilted Tokyo Station looks just like the real building. The zodiac circle appears in the sky, which adds to the element of fantasy. There are thieves hiding among the people waiting on the platform.

Above: In the upper right, Yoko has depicted herself as an older woman. She is purchasing snacks for the train ride. At the bottom, she has shown herself as a young child.

Below: A particularly magical part of this quilt is the somber colors of the Galaxy Express train and the transparent color of the star-studded sky, which seem to invite us on this journey into the unknown. Here too, once again, we see Yoko and her two cats as they are running toward the train.

Travel Advice—Under the Roof of Paris

While the theme of this quilt is inspired by a trip to Paris, 90 percent of this is based solely on Yoko's imagination. Rather than make an accurate record of her trip, she has instead created something completely original. First of all, there is no day or night, and tourist attractions that in reality are far apart have all been assembled close together. The time and place, and the people who are gathered here, cover a wide range of eras. Her comment about this quilt is that she has opened an atlas and has gone on a five-minute, twenty-three-second imaginary trip through the most elegant and curious parts of Paris.

Yoko has a penchant for transcending time and bringing day dreams to life. Her arts moves effortlessly along the vertical and horizontal axes. She has breathed life into every inch of this quilt.

The old Ferris wheel at the Place de la Concorde is filled with many colorful people. One couple is having an argument, while in another car, two boys are fighting. One person looks like he is about to fly off, while others ride calmly. Meanwhile, we see the hustle and bustle of the homes and shops depicted so vividly at the bottom of this scene.

◀ Yoko Sekita. *Travel Advice—Under the Roof of Paris.* 2014. 79 × 55 in. (200 × 140 cm). *Photo by Ayako Hachisu*

The famous twinkling neon lights and the iconic windmill of Moulin Rouge light up the sky. Traditional Japanese sashiko stitches create shadows in the indigo night sky. On the right, Opera actors are dancing in the sky while the Opera House is illuminated by blue lights in the background. The scene is rich with appliqué and embroidery.

A funny incident has occurred: Leonardo da Vinci has stolen his very own *Mona Lisa* painting and the museum's guards are chasing after him. The surrounding scenes depict the lives of Parisians in a very warm atmosphere. Every miniature detail has been perfected; the bars and storefronts are even named after famous artists: Cézanne, Toulouse-Lautrec, and Goya.

Wind God, Thunder God

This work is divided into upper and lower halves, depicting the worlds of both heaven and earth. In the upper half, Yoko has depicted the famous painting *Wind God, Thunder God* by Sōtatsu Tawaraya (1570–1643). This painting is familiar to Japanese people. The bottom half shows people running around in a sudden thunderstorm. Lightning roars from the heavens toward the earthly world. The violent thunder was caused by a fight between the two gods. The wind god, who creates the wind, has eaten a dumpling snack—which he stole—that belonged to the thunder god. This is a funny story that Yoko has made up.

These are nostalgic scenes from Yoko's childhood. There is a stall selling *takoyaki*, a Japanese soul food that is ball shaped and typically filled with octopus and other ingredients. A delivery man from a noodle restaurant has fallen off his bicycle, and in the process he nearly knocks over the man pulling the soba noodle cart. Other characters are from the Edo-era comedy books, Showa-era manga, and others. The girl who is being dragged is Yoko, and her mother has a tight grip on her because Yoko is fascinated with thunder and always ran outside as a kid to watch it. She is wearing her father's *geta* (traditional sandal footwear with a wooden base).

◀ Yoko Sekita. *Wind God, Thunder God*. 2020. 74 × 48 in. (187 × 123 cm). *Photo by Yuko Fukui*

Yoko has even brought Hollywood into this incredible work of art. A scene from the movie *Back to the Future* plays out, where Doc has climbed the tower to try to capture the lightning, while Marty and Einstein (the dog) wait by the DeLorean. Meanwhile, *Singing in the Rain* comes to life as Gene Kelly hangs off a light pole. And all of this takes place on the outskirts of Nagoya during a storm.

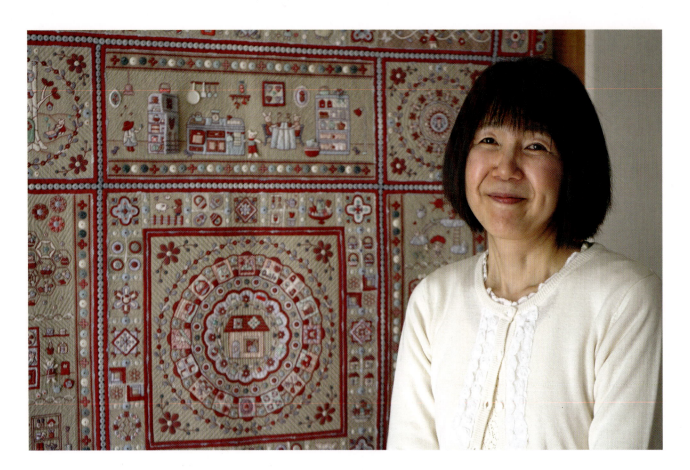

Aki Sakai
Snapshots of Holidays, Family, and Life

When I was one of three judges for the 2022 Houston International Quilt Festival competition, there was a collective gasp of awe when we were presented with Aki Sakai's entry. That quilt, titled *Merry Christmas,* was a wonderland of intricate appliqué that was simultaneously cheerful and technically impeccable. The sense of awe we experienced at first glance stems from her mature style of tiny, intricate maximalist appliqué that is visually held in check with a limited palette.

Aki invited Naomi and me to her lovely home in Hachioji, one of the special wards on the outskirts of Tokyo where modern, single-family homes are tucked together along tree-lined avenues. Inside her cozy kitchen and family room, we had a rare opportunity to see several of her quilts up close and hear her explanations and stories. Many of her quilts have a holiday theme simply because those themes are fun for her to think about and produce. Most are wall-hanging size, but she has also created spectacular mini quilts. For each quilt, Aki methodically selects a very limited color palette, usually just two colors, and because of this genius approach her quilts exude a soothing canvas where one can explore the maximalist imagery with ease.

▲ Aki Sakai in her home in Hachioji, near Tokyo. The quilt behind her is *Heartwarming Days*, and it is representative of her incredible originality, her storytelling abilities, and her brilliant use of a limited palette to keep the maximalist imagery in check. *Photo by Teresa Duryea Wong*

Aki has big ideas, but they are executed on a scale that is so small it seems impossible to create with human hands. Alongside her handmade appliqué characters are tiny objects she has purchased, such as buttons, hearts, combs, scissors, spoons, bows, and even a spider. But these are not ordinary objects, these are plastic or wood creations that are no bigger than a fingertip. These darling add-ons are sewn into the patchwork and further embellished with ribbons, lace, and beautiful embroidery.

Aki's quilts beg to be touched. She loves to incorporate hidden secrets, such as an oven or refrigerator with flaps that lift up to reveal an entirely new scene underneath. Inside the oven on her *Merry Christmas* quilt, one will find a turkey cooking for the family holiday. In the *Heartwarming Days* quilt, you can peek inside the refrigerator, and you'll see the family's favorite food and drink. On the *Happy Halloween* quilt, a pumpkin patch lifts up to reveal sugary treats lovingly created in her signature appliqué. Of course, everything is done by hand. Aki never uses a sewing machine.

When I first saw one of Aki's quilts in person, I was lured in by the kawaii aesthetic that was clearly constructed with the most exquisite technical detail. Each section of the quilt felt as if I was looking inside the window of a home where warmth and family were celebrated. Then, I was lucky enough to meet Aki and hear her talk about her quilts. And so it goes with all art: anytime you can hear an artist explain her work, you gain a much deeper appreciation.

As for Aki, I quickly learned that most of her scenes of family and daily life are snapshots of her own family, or memories from her childhood. These quilts are deeply personal, like a family photo album. One of my favorite stories she shared centers on one small block that depicts each member of her family. She has created her daughter as a joyful fan girl at a music concert, her son is studying and his expression

is stern, she's depicted herself in her garden and sewing, but the part featuring her husband is the one with the most character. He's pictured drinking beer and napping under a tiny quilt.

She has perfected some truly original techniques in her quiltmaking. One example is the way her quilts are assembled. She often will create a section and finish it with a binding, and that section will either be butted up against another similar-sized section, or she will connect two finished sections with hand-made yo-yos to create an airy essence to the finished piece. In addition, she often adds incredible, unexpected elements to the border that essentially break up the traditional boundaries of square shape by adding fabric loops, ribbons, or yo-yos. Gingerbread men, candy canes, dolls, hearts, lace, even tiny buttons along the borders seem to jump outside the confines of her quilt.

As a child, Aki wasn't interested in sewing or quilting, but she did love tiny things. Her mom collected all kinds of tiny objects, and that love of kawaii was passed on to Aki. These days, she has her own collection of glass miniatures, and they often inspire her artistically. In fact, one day she came across a super-small vintage frying pan, and that pan inspired an entire kitchen scene in one of her quilts.

Aki often creates a background for her blocks in a crazy quilt style, with irregularly shaped patches. The seams of the hand-pieced patches are usually covered with embroidery or ribbon. And then each small patch is covered with tiny appliqué humans, bears, dolls, trees and flowers, holiday objects, even an occasional octopus.

Quiltmaking became a part of her life in the early 1990s, when she went with a friend to a local quilt class. From there, she eventually signed on to take classes from master quilter Yoko Saito. She has great respect for Yoko Saito and appreciates the excellent

techniques she learned in those classes. However, as is typical with classes with traditional teachers in Japan, students are assigned a certain number of quilting projects each year and they must complete these assignments at home and bring them to class for evaluation. Aki felt overwhelmed by all the homework and eventually chose to discontinue studying with Yoko.

In hindsight, that decision was brilliant because it freed Aki to begin thinking about making quilts in a style that only she could dream up. Had she remained in the traditional *iemoto* instruction system (where students study with one master for decades), she would be expected to produce quilts in the style of her teacher. By stepping out on her own, Aki has been able to hone an aesthetic that is unique.

If there was only one word to describe that aesthetic, it would be joy. Her quilts make people smile. She has sometimes attended exhibitions where her quilts are on view, and she enjoys standing off to the side and watching people interact with her quilts. Seeing them smile and laugh, and get up close, brings her great personal satisfaction. That joy is her motivation too. She wants her quilts to be seen, not stuck in some drawer. So, she enters exhibitions and competitions all over the world.

Judges have noticed her impeccable style, and she has won numerous prestigious awards—including two Best of Show awards, one in Japan and another in the United States. Her *Merry Christmas* quilt was acquired for the permanent collection of the National Quilt Museum in Paducah, Kentucky, and Aki says that was a dream come true.

Awards

COATS & CLARK BEST WALL HAND WORKMANSHIP AWARD
American Quilters Society, Paducah. 2024.

BEST HAND WORKMANSHIP AWARD
American Quilters Society, Daytona Beach. 2023.

BEST OF SHOW
Pacific International Quilt Festival,
Santa Clara, California. 2023.

FIRST PLACE MINIATURE
Road to California, Ontario, California. 2023.

FIRST PLACE OTHER
Road to California, Ontario, California. 2023.

ACCUQUILT BEST WALL QUILT AWARD
American Quilters Society, Paducah. 2023.

SUPERIOR THREADS
BEST MINIATURE QUILT AWARD
American Quilters Society, Paducah. 2023.

MARIE WHITE MASTERPIECE AWARD
Road to California, Ontario, California. 2022.

THE GRACE COMPANY MASTER AWARD
Traditional Artistry, International Quilt Festival,
Houston. 2022.

BEST OF SHOW
World Quilt Festival in Yokohama, Japan. 2022.

▲ Aki Sakai. *Happy Halloween 2*. 2015. 52 × 55 in. (132 × 140 cm). *Photo by Ayako Hachisu*

Happy Halloween 2

Halloween is an exciting day for Aki, and she thrives on the anticipation of the fun that will happen on that day. This quilt shows her excitement, and she has conveyed the joy and surprise that comes from turning over a toy box and then the fun rolls out. As a child, Aki was obsessed with the tiny Glico Caramel bonus toys that came as a surprise in every box, and she has included some of those toys in this quilt.

The pieced background blocks are asymmetrical, somewhat of a crazy quilt style. But what's even more impressive is the fact that this quilt is constructed in sections, and each section is finished with a binding. Next, the sections are held together with very small yo-yos in between, which adds such an unusual finishing treatment, as well as texture. The yo-yo seams also add a strong graphical element to the quilt by emphasizing the unusual shape of each section.

These mini yo-yos are only 0.5 inch (1.5 cm) finished.

Above: This humorous setting is a quilt contest. On the far left is the grand prize winner of the contest, and the quilt made here for this setting is only 2.7 × 3.5 inches (7 × 9 cm). A tiny ribbon hangs next to it.

Below: Here we see a fun, and even slightly spooky, Halloween night filled with bats, spiders, and ghosts. The sewing basket contains actual miniature scissors.

Above: This pumpkin includes one of Aki's signature touches—the face is a flap that lifts up to reveal treats inside.

Below: This elaborately costumed Dracula is actually a handmade, stuffed doll. He is a mere 2.9 inches tall (7.5 cm).

▲ Aki Sakai. *Chima Chima Happy Quilt.* 2017. 54 × 55 in. (136 × 140 cm). *Photo by Ayako Hachisu*

Chima Chima Happy Quilt

This quilt is a treasure to commemorate Aki's twenty-fifth wedding anniversary. She features a 19.6-inch (50 cm) square block in the center and created twelve square blocks of 9.8 inches (25 cm) each to surround it. Each block combines crazy quilt–style shapes. Memories of her family and of time with her husband are lovingly depicted in each section, along with a few favorite things of her own that are sprinkled in.

The scenes she depicted include her wedding, time living in the US in Ohio, happy memories with her two children, and memories of her father, who passed away at the age of eighty-two. The brick-like border is meant to reflect the many years her father cared for his family. Aki feels she has documented a great deal of her life, and personal memories, in this quilt.

The title *Chima Chima* comes from a Japanese slang term that means something is overly detailed.

Here Aki has captured a daydream, which is to own a nice café. Inside we see a teddy bear serving his customer, Sunbonnet Sue.

Here another daydream—owning a quilt shop—is depicted. Actual spools of thread and lace are included, buttons are sewn, and there are even tiny embroidery hoops with embroidered characters. All of these embellishments lend the quilt shop a three-dimensional aesthetic.

This block oozes nostalgic Japan via a retro candy shop. At one point in history, there were small shops like this in every town in Japan and children always gathered there. Aki has included a vintage record player, refrigerator, TV, toys, and even elementary school lunches from forty or fifty years ago.

Aki's father loved to play golf, climb Mt. Fuji, and pick grapes from local vineyards. She has forever recorded these pastimes here, along with his endearing smile, which she will always remember.

Aki has fond memories of being at the beach and swimming in the sea with her family. Here, she has mixed reality and fantasy together to create an octopus, a turtle, and other sea creatures, as well as swimsuits and actual tiny sunglasses. There is a hidden treasure on a sunken ship. And in the center, a sweet boat with a fishing line. A darling mermaid watches over everything.

Merry Christmas

Aki takes the mini idea to a whole new level in this tiny quilt. The center block measures just 5.5 inches square (14 cm), and the surrounding blocks are 3.5 inches (9 cm). The whole quilt is meant to look like a pop-up children's book, with plenty of three-dimensional motifs. What brings this lively quilt all together is the precious border design, which is an elaborate finish featuring miniscule yo-yos inserted inside small loops. Each yo-yo is 0.3 inches (1 cm). Both the yo-yo and loop are attached to the innovative binding. Each yo-yo is embellished with one super-tiny bead. The basket with the gingerbread man is only 2.7 inches tall (7 cm), and the Sunbonnet Sue standing in front of the fireplace is about the size of a fingertip. She measures just 1.3 inches long (3.5 cm).

◀ Aki Sakai. *Merry Christmas.* 2016. 18 × 18 in. (45 × 45 cm). *Photo by Yukari Shirai*

Joyful Heart

When Aki's husband celebrated his fiftieth birthday, and her son celebrated his twentieth birthday, Aki found the perfect opportunity to make a quilt commemorating this important family milestone. This quilt certainly exudes her love for her family. The colors are red, light blue, and white. Each block records so many memories. The appliqué in outer blocks uses rounded shapes and this treatment provides a soft impression to the overall piece. And Aki took this detailed appliqué even a step further by highlighting the edges with red thread to give them definition.

The block with six rooms inside a house is 12.9 × 12.2 inches (33 × 31 cm).

Around the edges, Aki has added hearts and flowers that extend the frame of the quilt outward.

◀ Aki Sakai. *Joyful Heart*. 2013. 59 × 54 in. (150 × 137 cm). *Photo by Yukari Shirai*

▲ Aki Sakai. *Blue Tone*. 2012. 51 × 51 in. (130 × 130 cm). *Photo by Yukari Shirai*

Blue Tone

Back in 2012, this was the first large-size quilt Aki had ever made and she created it to celebrate her twentieth wedding anniversary. She has combined many different quilt themes, such as the romantic Double Wedding Ring pattern with ribbon-shaped appliqué and an extraordinary amount of hand embroidery. This quilt reads like a diary where her family is charmingly depicted as bears. Her family home takes center stage and the overall palette of light blue and cream exudes a calming effect.

Here we see the family of four depicted doing things they love most. Her husband is drinking beer and napping under a quilt. Her son is studying in order to pass the university entrance exam. Her daughter, who is obsessed with music idols and loves sweets, is shown cheering as a fan at a concert. The artist has depicted herself gardening and quilting.

Through appliqué and embroidery, Aki creates a collage-like effect in order to express her own unique ideas.

This block is meant to commemorate the twentieth year of her marriage with the traditional Double Wedding Ring pattern. The birds surrounding it represent her friends and family members who have been a part of their lives for two decades.

She has recorded her family inside their home at the time, and it is a precious memory of those happy days.

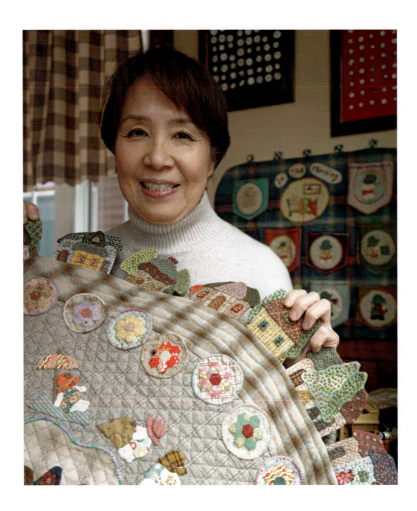

Reiko Kato
International Appeal Rooted in Japanese Color

Reiko Kato has discovered that the best way to be a successful, international quilt author and teacher is to simply make what she loves the most, because when she stays true to her own style of appliqué created in her signature taupe palette, Reiko's students and followers also fall in love with her creations.

Reiko began her teaching career in 2000. I first met her in 2014 at her quilt shop and teaching studio called Mother's Dream in Edogawa-ku, Tokyo. At that time, she was already a sought-after teacher and had published several international quilt books. I was invited to attend some of her classes and got a firsthand experience with the *iemoto* (master) style of teaching. *Iemoto* is a well-known Japanese teaching system where students receive highly detailed instruction from a *sensei* (master teacher) and are expected to make art closely aligned with their instructor's style. Reiko has adapted the basics of *iemoto* teaching, but she is a gentler teacher and allows her students the freedom to experiment and make what they want.

▲ Reiko Kato is the owner of Mother's Dream, a shop in the Edogawa area of Tokyo. She is an influential teacher and has inspired many longtime students in Japan, as well as in France and Europe, where she teaches regularly. *Photo by Teresa Duryea Wong*

In the decade since we first met, Reiko's popularity has continued to soar, especially in France where she is a beloved quilter and teacher. In recent years, she has published several additional instruction books that are bilingual in French and English. She is regularly invited to exhibit her quilts in France, and she travels there annually to host a retail vendor booth at Pour l'Amour du Fil, a large quilting event held in Nantes.

Reiko does not enter her quilts into competitive judged shows, but she does organize regular exhibitions of her quilts, and her student's quilts, in France and Japan. Her annual shows at a small art gallery in Japan are a point of pride for many of her students who proudly bring their friends and family to see hanging in a quilt exhibit the beautiful handmade creations they worked so hard on.

Reiko continues teaching at her studio back home, and she and her small staff run the retail quilt shop. In fact, she recently relocated her studio and shop closer to her home—so close, in fact, that Mother's Dream is literally just a few steps from the front door to Reiko's home, which is also in the Edogawa area. By eliminating the commute back and forth to her store, Reiko has freed more personal time to be with her husband and two grown children, and more time to make quilts. She often turns to quiltmaking late at night in her home when the house is quiet, and she has time to finally relax.

All of Reiko's quilts are constructed in the earthy palette of tan, brown, cream, gray, pearl, rust, and light greens, even a tiny bit of midnight black. Reiko feels that this special set of colors is very dear to the Japanese because these are the colors of the earth, and the natural world. Interestingly, Reiko points out that these earth tones are also the color of the pottery and dishes in her home.

The term *taupe palette* is quite well known in the international quilt world, thanks to my coauthor Naomi Ichikawa, who first coined the term *taupe* to describe this aesthetic. Naomi is a veteran of Japan's quilt magazine publishing, and she wrote an article about this in 2003 in which she coined the taupe descriptor, and since then the international world has wholeheartedly adopted Naomi's term.

Besides the taupe palette, Reiko's signature appliqué features many traditional quilting motifs, including her kawaii Sunbonnet Sue characters, which she feels are both classic and contemporary motifs that she can manipulate to exude a lot of personality. She appliqués these Sues against tiny houses and sweet flowers, and the viewer's eye can travel along block after block of the miniature characters in a variety of outfits and poses within each charming scene. Her characters bend and move as if they've come to life.

Reiko Kato is comfortable with her style, and she is so accomplished at making what she loves, that it's easy for her to pass on her knowledge to her students, whether they are in Japan or France. Her longtime Japanese students travel from all over the country to attend classes at her studio in Edogawa, as they've done for decades. She also hosts workshops in Europe, most often in France. She loves France so much that she is studying the French language so she can get even closer to the quilters who appreciate and admire her tiny appliqué worlds created entirely in her earth-tone, taupe palette.

▲ Reiko Kato. *Peaceful Time—My Second Circle Quilt.* 2023. 40 in. (104 cm) dia. *Photo by Yuko Fukui*

Peaceful Time—My Second Circle Quilt

With her unusual round-shape quilt, Reiko is repeating the shape of the earth. She is so happy to know that she has quilting friends all over the world, so she felt that the round shape reflected her world view on quilting. The composition is centered on a Sunbonnet Sue who is watering flowers made of hexies.

Reiko's mainstays in her quilts are her houses and numerous Sunbonnet Sue figures. She keeps these motifs interesting by depicting the Sues as if they are seemingly in motion, moving about the quilt. She relies on memories of her two children and how they moved around when they were little, and those memories are the perfect model for her lively appliqué.

In the close-up of the center, the Sunbonnet Sue holding the watering can is a mere 2.7 inches tall (7 cm). Each of her figures is bordered with colored thread to add definition to their tiny shapes. Each house has its own unique characteristics, and the homes are embellished with sashiko-like stitches. They are packed tightly together because the people here live in close harmony with one another.

Four Seasons of Sue & Billy

There are four horizontal sections to this quilt, one for each season, spring, summer, fall, and winter, separated by tree branches. The children are scrambling around and are actively engrossed in their play during each season. Each figure has its own distinctive outfit, and these tiny figures measure just 2.5–3 inches (7–8 cm). In the spring months, children are playing in the warm sunshine. For summer, they bring out umbrellas, plastic pools, and cute swimsuits. Autumn is for apple picking and Halloween, when the leaves are falling. Winter is for the snowy Christmas holiday, and snowmen abound.

▲ Reiko Kato. *Four Seasons of Sue & Billy*. 2015. 44 × 47 in. (112 × 120 cm). *Photo by Yukari Shirai*

Hand in Hand

This brilliant quilt took Reiko two years to make. There are twelve individual blocks that are connected together ever so delicately to form a whole. The blocks vary in size, with each side measuring between 11 and 15 inches (30 and 45 cm). The Sunbonnet Sues are approximately 2.5 to 3 inches tall (±6 cm).

Each block is decorated slightly differently, with a wreath of appliqué and embroidered flowers around the center motif. Reiko has perfected an unusual embroidery technique to serve as both the binding and the connectors for the center blocks. Because of this innovative design, this quilt seems so airy, and the centers of each block seem to be floating above the surface. Handmade three-dimensional flowers connect blocks.

◀ Reiko Kato. *Hand in Hand*. 2017. 59 × 47 in. (150 × 120 cm). *Photo by Yukari Shirai*

▲ Reiko Kato. *Around the World*. 2013. 47 in. (120 cm) dia. *Photo by Yukari Shirai*

Around the World

This is the first circle quilt that Reiko made. She created this piece with the hope that it would make everyone feel warm and at peace. The large outer circle of Sunbonnet Sues joined by holding hands is a cherished idea of hers—hoping that all people could join hands in this same way. In the center, three girls are playing on a slide, while others are doing exercises before jumping in the swimming pool. A ring of daisies circle the children at play.

Akiko Yoshimizu
Beauty in Symmetry

Akiko Yoshimizu doesn't own a sewing machine, and in this way she is like a lot of Japanese quilt-makers who prefer the technical precision and soft stitches that they believe can only be achieved with hand sewing. While Akiko may share the same hand-sewing process as her fellow quilters, the similarities end there.

Her quilts are extraordinary works of art with highly original designs. She is most known for her large quilts with repeating rows of appliquéd and brightly dressed miniature girls. Some of her quilts feature more than 1,000 of these characters, who are all smiling, or even winking, at the viewer. No two of these doll-like figures are alike, and the overall effect can be breathtaking.

Akiko's mother was a powerful influence on her when she was growing up. Her mother was a painter, and she also loved sewing and making traditional kimonos. Akiko remembers her mother praising her frequently and encouraging her to be artistic. Later in life, Akiko's mother came to live with her, and she stayed healthy and active until the age of 100, when she needed more care and moved to a nursing home. She passed away at the

▲ Akiko Yoshimizu lives in a modern apartment complex in Ashiya City, in the Hyōgo Prefecture. Her sunny home and modern building are a perfect fit for her bright, cheery, and incredibly artistic quilts featuring doll-like girls in fancy dresses. *Photo by Teresa Duryea Wong*

age of 102, and she left Akiko an incredible stash of gorgeous silk kimono fabrics. Akiko turns to those fabrics over and over for her quiltmaking, and when she does, she feels she is carrying on her mother's memory through this cloth.

There is never a shortage of ideas in Akiko's sharp mind. She says that ideas come to her like water in a fountain, that they rise up in an endless stream. Before she even finishes one quilt, she has worked out the concept for the next one. Because of all the handwork and intricate detail, Akiko spends one year or longer to finish just one quilt.

She shares a home with her husband in a modern, midrise, multifamily complex in Ashiya City, a leafy, hilly town near Kobe. Ashiya is picturesque and is one of those places that is a big city with a small-town feel. The town faces Osaka Bay and is ringed with mountains, and what's more, the river is lined with cherry trees. From inside their home, Akiko is fortunate to have a small room dedicated to storing her quilts and fabric collection. In addition to her mother's fabric, she also has silks that once belonged to her grandmother, and scraps from a relative who was a professional dressmaker. Akiko is generous with her stash, and she offered to share pieces of this gorgeous fabric with us during our interview. Some of that antique silk fabric has found a new home in Texas.

There is beauty in symmetry, and Akiko's quilts are the epitome of symmetry. She creates hundreds of repetitive appliqué blocks, one quilt even has 1,500 blocks, and packs them tightly together, and assembles rows and rows of symmetrical shapes. While the symmetry draws you in, the closer you get to the surface of these quilts, the sooner you start to see the variety of each figure. Here is where the magic starts to shine. The many different fabrics and poses, the complexity of the tiny details, adds yet another layer to the splendor of this art.

Akiko starts each appliqué figure by selecting a solid background block—usually only about 5 inches tall—in a carefully curated color. Her artistic choices for colors enable an overall gradation of color, or carefully shifting regions of color, and this helps keep the many appliqué figures grounded. Sometimes the color change is managed by changing the background fabrics where she creates gradation with slight changes in color. For example, dark blue around the outside edges while ever lighter shades of blue blocks surround the center area. In addition, sometimes the colors used for the girls themselves evolve so there are rows with predominantly pink, or purple, or red.

Her first step is to attach the face, arms, and legs of each girl to the background block. Because of the needle-turn appliqué, when finished, the inside of each tiny arm or leg, or dress, is densely packed with seams from several layers of fabric, and as such, they look almost like they are stuffed. Their tiny arms, faces, and colorful clothes lift off the surface of the quilt for a semi-three-dimensional effect.

Next comes the fun part—dressing them. Each little human is dressed in a unique outfit, complete with curly hair and fancy shoes, sometimes even a darling tiny colorful purse. And Akiko says choosing fabrics for these outfits and purses is one of her favorite moments. In one quilt, she fashioned each character with an umbrella and a purse, which offered her even more opportunities for creativity. By including umbrellas, Akiko hopes her viewers will think of how life can still be fun and colorful, even if it's raining.

In addition to the fancy dresses, Akiko sometimes creates girls dressed in traditional Japanese clothes, such as one quilt featuring young girls wearing *furisode* (kimono with long sleeves, worn only by young, unmarried women). Instead of purses, these girls have colorful *obi* (waistband sashes around the kimono). Some of the girls are even

facing backward, so we can see the elaborate traditional *obi* at the back of the kimono.

She has perfected a technique to create hair for each of her figures, using a special curled embroidery floss she discovered at a local shop and extremely tiny and tightly packed French knots. The end result gives each girl a full head of curly hair in a variety of long and short styles. Not only are the hairstyles curly, but the colors are very international, with blond, brown, red, yellow, white, and gray hair colors. Altogether, the hairstyles, hair bows, pigtails, and mix of lengths make a colorful fashion statement all on their own.

Akiko has always loved dolls, and her quilts certainly exude that fondness. She cherishes the Hina Matsuri festival season, and she still has many of the *hina* doll sets that were given to her over the years, as well as some of those that have been passed down in her family. She has a large cabinet that is full of *hina* dolls, and she admits she is a passionate collector of tiny, tiny *hinadan* (*hina* doll displays). Some are so small that you almost need a magnifying glass to appreciate them.

The dolls in her display cases, and throughout her home, are a huge inspiration for her quiltmaking. By working only with her hands, which Akiko calls her machine, she seeks to re-create a darling fashion show of kawaii doll-like girls. Not only are they colorful, but these dolls are also impeccably made. Nothing short of perfection in each and every stitch is acceptable. That's why you will find several ribbons from international quilting competitions tucked among her *hina* dolls and kawaii collectables. She is proud that her quilts are accepted to international competitions, because she wants people to see them and enjoy them, and these ribbons are proof that her quilts are not just enjoyed but revered.

With every stitch, every piece of fabric, and every kawaii creation, Akiko is showing the global world how she combines incredible artistry with her Japanese aesthetic to create unforgettable works of art.

Awards

APQS JUDGES' RECOGNITION AWARD
Ricky Tims, American Quilters Society, Paducah. 2024.

FIRST PLACE, APPLIQUÉ
International Quilt Festival, Houston. 2022.

HEARTWARMING AWARD
Tokyo International Quilt Festival, Tokyo. 2020.

HEARTWARMING AWARD
Tokyo International Quilt Festival, Tokyo. 2019.

SPONSOR AWARD
International Quilt Week Yokohama, Yokohama. 2012.

EXCELLENCE AWARD
International Quilt Week Yokohama, Yokohama. 2011.

ENCOURAGEMENT AWARD
International Quilt Week Yokohama, Yokohama. 2009.

SPONSOR AWARD
International Quilt Week Yokohama, Yokohama. 2008.

EXCELLENCE AWARD
International Quilt Week Yokohama, Yokohama. 2004.

EXCELLENCE AWARD
International Quilt Week Yokohama, Yokohama. 2002.

1500 Kimono Girls

There are 1,500 girls in this extraordinary quilt. Each girl is exactly the same size—2.5 inches (6.5 cm). Each block with an appliqué girl is made one at a time, then the blocks are pieced together with careful attention to color. Akiko expertly kept a perfect balance in color with the gradual shift from dark colors to light.

▲ Akiko Yoshimizu. *1500 Kimono Girls*. 2017. 77 × 82 in. (196 × 210 cm). *Photo by Yukari Shirai*

These girls are so kawaii. Each one has a fashionable, interesting tiny cotton print for the kimono. No two kimonos are the same! Also, the *obi* (sash), *obijime* (braided cords), and cute hairstyles with perfectly placed hair ribbons are all very stylish. The girls' hair colors range from blond to brown, and a few have black hair. The trick to making these girls look so cute is to embroider only the eyes and the mouth, leaving out the nose.

The colors are arranged in a rainbow-colored gradation. Many of the light-colored prints used here are delicately reminiscent of cherry blossoms in the spring. The set of warm colors, such as the pink kimono, is carefully placed next to the cool colors, such as the stylish brown, and these choices provide a perfect contrast and keep the repetitive aesthetic riveting.

Akiko has taken great care to tie each *obi* properly, which is important in Japanese tradition. The most popular way to tie it is to form a bow in the back, which is especially popular among the younger generation. Some of the girls are randomly featured from the back, which not only adds variety but allows the charming *obi* bows to show.

Just like in a real kimono, Akiko has included the *ohatshori* (fold around the hips that is created by tucking excess fabric to make the kimono fit). That takes a lot of work on a girl that is less than 3 inches tall, and this incredible attention to detail is a perfect explanation for the incredible mastery and beauty of this quilt.

▲ Akiko Yoshimizu. *Cherry Blossom Girls*. 2021. 83 × 83 in. (210 × 210 cm). *Photo by Yukari Shirai*

Cherry Blossom Girls

Akiko admires the height of foreign fashion models seen on the runway. So, for this quilt, she decided to give her Japanese girls the long legs and elongated bodies of fashion models.

There are 640 pink background blocks, each measuring 4.7 × 1.9 inches (12 × 5 cm). The doll-like teenage girls measure just 4.1 inches (10.5 cm). Each outfit is unique, and she kept the patterns interesting by varying the length of the dresses and by adding a special design for the purses each girl carries. Their hair color ranges from blond to dark brown.

When viewed from an angle, the symmetry and variety of color look amazing. These girls could step off the quilt and right onto a New York runway.

▲ Akiko Yoshimizu. *Happy Time*. 2001. 75 × 75 in. (190 × 190 cm). *Photo by Yukari Shirai*

Happy Time

Akiko had always wanted to make a red-and-black quilt. She was inspired by the happiness of sitting in a garden filled with roses. She has created 181 girls on a black background, which makes the brightly colored girls really stand out. Each background block is 3.1 inches (8 × 8 cm) square. In between each girl, the sashing is bow shaped, and handmade red yo-yos are set in each corner. There is a double border, which adds a rich quality to the finished aesthetic.

The girls are preteens, ten to thirteen years old, and each one is seated. They are 2.5 inches tall (6.5 cm). Akiko keeps changing the position of the arms and legs in order to keep the motif interesting.

▲ Akiko Yoshimizu. *Dress-Up in Furisode*. 2009. 78 × 80 in. (198 × 202 cm). *Photo by Yukari Shirai*

Dress-Up in Furisode

Japanese girls often wear a *furisode* for coming-of-age ceremonies. A *furisode* is a kimono with long sleeves that can be worn only by unmarried women. After marriage, women switch to a *kosode*, a short-sleeve kimono.

When it was time for Akiko's daughter to celebrate her coming-of-age ceremony, she chose not to wear a *furisode*. Because Akiko never saw her daughter wearing a *furisode*, she decided to make a quilt filled with young women in their beautiful *furisode*. The base of each girl is a pieced hexagon that is 3.9 × 1.9 inches (10 × 5 cm). The girls measure just under 3 inches (7.5 cm). As is so true of her style, Akiko has made each girl unique, with colorful prints for the kimono and cute hairstyles and hair bows.

In addition, she made the unusual decision to tie this quilt, rather than stitch it, and the red ties add a really special textural feel to the finished quilt.

▲ Akiko Yoshimizu. *Cupboard Girls.* 2010. 79 × 79 in. (200 × 200 cm). *Photo by Kimiko Kaburaki*

Cupboard Girls

This quilt has a funny backstory. Akiko is a collector of all sorts of things, and she wanted to find a nice cupboard to display her collection of coffee cups. But she never found a cabinet that really suited her needs. So instead, she decided to make a quilt featuring a cupboard filled with darling cups and saucers, but she thought they might be a bit lonely, so she added young girls playing hide-and-seek in the cupboard. As they climb about, we see their curiosity at play as they explore this cool collection of cups. A few girls are tuckered out and just lying around. Each girl is just under 3 inches (±7 cm). The brown cupboard shelves allow the cups and the girls to really stand out. The playfulness of this quilt, and the exquisite attention to detail, makes it special.

Summer Girl

For this quilt, Akiko wanted to create each girl as if she was standing inside a box. When she was a child, she loved to look at the dolls in boxes lining the toy-store shelves, and she layered those memories into this quilt. There is an additional meaning behind this quilt. In Japan, there is an expression—"a boxed girl"—which means a young girl who is spoiled by her parents and lives a perfect life just like a doll in a box.

There are 100 girls wearing summer dresses in pastel colors. The varied dress lengths add a touch of individuality to each girl, who measures just 3.1 inches (8 cm).

◀ Akiko Yoshimizu. *Summer Girl* (detail). 2022. 40 × 21 in. (102 × 53 cm). *Photo by Ayako Hachisu*

Megumi Mizuno
Exquisite Borders Surround Colorful Montages

Quilters around the world were devastated to learn in 2021 of the closure of the Tokyo International Great Quilt Festival. It was the world's biggest quilt show, and everyone called it the Tokyo Dome show. Tens of thousands of quilters made an annual trek to Japan each January to attend. Megumi Mizuno was intimately involved in the show and loved going, but when it closed, there was one positive thing that came from that decision—it relieved the pressure of making a world-class quilt exactly every twelve months. In Megumi's world, it would be unthinkable to exhibit a quilt that wasn't absolutely perfect, so while she loved the challenge, the pressure was immense.

Her quilting journey began in the 1990s when she lived in Fukuoka, on the island of Kyushu. Megumi happened to spot a quilted bag in a store window. She went inside and discovered that she could take a class to learn how to make a quilted bag. She signed up immediately, and after that, she was hooked on quiltmaking. Since that first encounter, Megumi has won dozens of top quilting awards from around the world, and she has produced a lovely book with

▲ Megumi Mizuno is a quiltmaker, a teacher, and the author of an international quilting book of her designs. She's pictured here at her home in Shiki, in Saitama Prefecture. *Photo by Teresa Duryea Wong*

patterns and instructions on how to construct her quilts in English and French.

For many years, Megumi's husband worked in the banking industry, and he was transferred to different cities all over Japan every few years. Throughout the moves, she wanted to learn more about quilting and find a class that could help her develop better skills. She came across a book by the famed *sensei* (master teacher) Yoko Saito, and as they say, the rest is history. Megumi began taking classes at the Nihon Vogue school under Yoko Saito, whom she describes as her personal hero. As her technique matured, Megumi eventually excelled in the classes and moved up the chain in the well-defined student/teacher structure of the *iemoto* (master) system. Megumi eventually became a master student of Yoko Saito. And of course, this created opportunities for her to exhibit her quilts at the esteemed Tokyo Dome show before it closed.

Learning under the instruction of Yoko Saito has been a point of pride for Megumi for the past twenty-five years. She has deep respect for her and feels that Yoko's techniques and artistry are impeccable. While she has graduated from the traditional class system, Megumi continues studying privately with Yoko Saito.

Over the years, Yoko Saito has complimented Megumi on her quilts, and those words are especially meaningful and encouraging to her. Megumi is now certified to teach under the Quilt Party system. Quilt Party is the name of Yoko Saito's retail store and global business, and the teachers who are certified under this system pass on the techniques in the same way Yoko taught them. In addition, both the teachers and the students aspire to make quilts in the same aesthetic as Yoko Saito's quilts.

While some of Megumi's quilts have the same underlying taupe palette as Yoko's, she has created room for experimentation and often adds strong primary colors to the background, or colorful appliqué, embroidery, and embellishments. Her playful scenes are often inspired by dolls, especially *kokeshi* and *daruma* dolls, and she has mixed these traditional Japanese dolls with dolls from other cultures, especially *matryoshka* dolls from Russia. In addition, Megumi worked as a graphic designer and a manga artist as a young woman, and those skills and experiences have been translated to her quilt design.

One of the most striking elements of Megumi's quilts is the incredible borders she creates. These borders almost steal the show, but instead they form stunning frames around her kawaii characters and cheerful scenery. These borders are complex and chock-full of imagery and pattern. Some borders feature hundreds of small flowers embellished with beads and buttons and then outlined with vines and leaves. Another border is a rich tapestry of dolls and architecture that move your eye around the perimeter of the quilt.

Ideas come to her all the time, especially when she is walking in her neighborhood in the town of Shiki, in Saitama Prefecture. The home she shares with her husband sits on a winding, narrow street, and her well-lit dining room doubles as her sewing space and classroom where she teaches small groups of students.

In addition to quiltmaking, Megumi also loves to sew garments. She says laughingly that in her next life she wants to be a fashion designer. The clothing she makes for herself carries that same impeccable craftsmanship seen in her quilting. Everything is perfectly finished and even her personal touches to the traditional Japanese sewing patterns are exquisite. And unlike most other quilters in Japan, Megumi is active on social media and enjoys posting and sharing images of her garments and quilts online.

The sewing bug has skipped a generation in her family, so even though her daughter does not sew,

her young granddaughter is learning. The grand-daughter often places "orders" with Megumi for special costumes. Megumi laughs when she says her granddaughter thinks she is a magician who can whip up an outfit or a costume in no time at all.

Whether she is making lovely quilts or sewing a new outfit, Megumi is an extremely talented maker with decades of experience. Her quilts are a joy to study. They are slices of Japanese life mixed with culture from all over the world. And these days, it is also a joy for her to create new quilts without the pressure of an exhibition deadline for what was once the world's biggest quilt show.

Awards

ENCOURAGEMENT AWARD
Tokyo International Great Quilt Festival, Tokyo. 2003.

FIRST PLACE, APPLIQUÉ
International Quilt Festival, Houston. 2003.

FIRST PLACE, HAND QUILTING
International Quilt Festival, Houston. 2004.

HAND QUILTING AWARD
Tokyo International Quilt Festival, *Tokyo. 2006.*

FIRST PLACE, HAND QUILTING
International Quilt Festival, Houston. 2006.

ARTISTRY MASTER AWARD
International Quilt Festival, *Houston. 2008.*

FIRST PLACE, FIRST QUILT ENTRY
American Quilters Society, Paducah. 2009.

SECOND PLACE, HAND QUILTING
American Quilters Society, Paducah. 2011.

FIRST PLACE, INNOVATIVE
International Quilt Festival, Houston. 2011.

SECOND PLACE, HAND QUILTING
American Quilters Society, Paducah. 2024.

In Love with Dots and Dolls

Approximately fifty Russian *matryoshka* dolls appear in this quilt. There is a plethora of polka-dot prints in the background, giving it a colorful fun look. Many of these dolls are meant to represent friends and family and Megumi has embroidered their names on each. The dolls vary in size from 1.5 to 6.6 inches (4 to 17 cm). Hidden among the rows of mushrooms is one small girl. Each mushroom measures just 2.3 inches (6 cm). There is a rabbit *matryoshka* doll set and they are decorated with sequins and Megumi's incredible embellished tiny three-dimensional balls. She has even added yo-yos, which, from a distance, add to the polka-dot theme.

Megumi Mizuno. *In Love with Dots and Dolls*. 2010. 59 × 79 in. (154 × 200 cm). *Photo by Yukari Shirai*

▲ Megumi Mizuno. *The Story of the Kokeshi.* 2019. 72 × 80 in. (183 × 204 cm). *Photo by Yukari Shirai*

The Story of the Kokeshi

This quilt is a tribute to the simple but cute wooden Japanese dolls known as *kokeshi* dolls. Megumi has given each doll her own unique expressions and characteristics and she has varied the position of their eyes. Their black hairstyles range from a short bob style to buns, which is so typical of the many cute ways that young Japanese women style their hair. Each doll measures 1.1 to 10.5 inches (3 to 27 cm).

The exquisite embroidery work adds an entirely new level of detail to this quilt. Her creativity in making these dolls is endless. There is a Playboy bunny doll, a Halloween pumpkin doll, even a Santa doll. A *kokeshi* train filled with dolls and decorated with blooming flowers is especially cute. In one block, the dolls form a circle, and the word *kokeshi* is appliquéd in the center. The size of that block is 9.8 inches (25 cm) and the small dolls are just 3.5 inches (9 cm).

The *kokeshi* doll in the top left is Thumbelina, and the doll
next to her is a typical *kokeshi* doll from the Tohoku region.

Daruma:
Fall Seven Times, Stand Up Eight

The daruma doll is an oval-shaped doll with a slightly wider rounded base. It is a beloved doll because it stands up even if it falls down. It is said that there once was a monk named Bodhidharma, who practiced *zazen* (sitting in Zen meditation) for nine years, and because of that, he lost his arms and legs. Thereafter, he became known as Daruma. Megumi embroidered the words *Fall Seven Times, Stand Up Eight*, which are the words of Bodhidharma. She made this quilt to express her wish to stand up without giving up when everything came to a halt during the COVID-19 pandemic.

The border has an incredible design. The *daruma* are featured in reverse color schemes, red on gray and gray on red, and presented in a perfect mirrored pattern. Outside of that, there is another border filled with embroidered circles, and the combination of these two stunning designs really makes the whole border sparkle.

◄ Megumi Mizuno. *Daruma: Fall Seven Times, Stand Up Eight*. 2023. 68 × 80 in. (172 × 202 cm). *Photo by Yuko Fukui*

These 3.1 in. (8 cm) dolls each have a yellow mimosa flower embroidered on their belly.

Gold *daruma* are especially auspicious. The embroidered butterfly pattern is a traditional Japanese design.

This little *daruma* even looks cute in glasses.

Hiroko Akita
Delightful Dollhouses, Tiny Quilts

Hiroko Akita makes quilts that are so tiny they could fit in the palm of your hand. This wasn't always the case though. She started out the way most quiltmakers start, by making traditional patchwork quilts to use and to exhibit. She joined a local quilting group, and they exhibited quilts annually. Then, after the exhibit was over and everyone started looking forward to next year, the beautiful quilts of yesterday ended up stored in a drawer somewhere, forgotten and unused.

Eventually, Hiroko grew tired of expending so much time and energy on something that went straight to storage, so she decided to try something new—tiny dollhouses. After much experimentation and reflection, she has settled on an aesthetic for her dollhouses, which are finely tuned masterpieces in interior design.

Part of her artistic discovery that has enabled such sharply designed interiors has to do with the fact that Hiroko's exquisitely dressed dolls have no

▲ Hiroko Akita began her quilt journey making traditional quilts. These days she makes quilts no bigger than a couple of inches. The handmade dollhouse next to her is decorated for the Hina Matsuri celebration. *Photo by Teresa Duryea Wong*

heads. They are simply mannequins with the finest tailor-made clothing you can imagine. By Hiroko making the bold decision to eliminate the head, viewers can instead focus on the clothing and objects in the scene, rather than being absorbed by a doll's face. This creates an opportunity for viewers to imagine their own story, and whatever face they choose to recall, within each scene.

Finding the fabrics to dress these dolls and decorate their setting is not easy. Any fabric with a large motif is out of the question because a big design would overpower these tiny objects. Instead, Hiroko must carefully seek out prints with tiny, tiny flowers or graphics on a scale that is befitting of a dollhouse. She always studies the fabric up close to see if any of it can be used. If she's lucky, there will be a series of miniature flowers floating off to the side of a large central flower. Or deep within a primary design, there might be pattern within pattern that she can cut out and use. These little specks of color are usually just castaways from the main design, yet in Hiroko's hands they become the main event on a 5-inch doll, or a 1-inch pillow.

While some quiltmakers might find the task of making a traditional, large appliqué album quilt daunting, imagine making that same pattern where each block is no bigger than a fingertip. Hiroko's

album quilts look every bit as stunning as one large enough to cover a bed. She admits to three secrets to her success in making these tiny quilts. First, she wears a set of intense magnifying eyeglasses. Second, the appliqué is fused, not sewn. And last, her fingernails are her most accurate tool for the precise placement.

Hiroko's childhood was filled with tiny things, and she especially loved *hina* dolls. Growing up her older brother would buy her *hina* dolls, as well as dollhouse furniture and objects as gifts. He loved Japanese history and the idea of small, traditional things appealed to him, and he passed that love on to his sister. In fact, Hiroko has a collection of *hina* dolls that includes a set that has been in the family for 120 years.

But it is her modern-day dollhouses, with tiny quilts on the walls and on the beds, and quilted pillows, plush tablecloths, minuscule flower arrangements, and extraordinary furniture pieces, that have captivated the imaginations of viewers. Unlike Hiroko's traditional full-size quilts from her former artistic life, these stunning little pockets of scaled-down beauty are sure to be displayed where they will be seen. After all, you only need a space the size of a hand to showcase and adore one of these tiny treasures.

One Incredibly Small Dollhouse, Three Even Smaller Quilts

Pictured here are four views inside one incredibly well-decorated, very small, two-story dollhouse expertly crafted by Hiroko Akita. This dollhouse is quite different from Western dollhouses. Here we can see the living room and the small attic room on the second story. Akiko's design—and the overall small scale of this work of art—fits perfectly inside small Japanese homes. Everything except the furniture is handmade. There are two quilts on the walls, and one quilt on the bed. Even the apron on the model is a patchwork design. The ever-so-tiny pillows and clothing are exquisitely made. Hiroko has even constructed extra quilts and pillows and clothing so the house decor can be switched to reflect different seasons.

The Baltimore Album quilt in the living room is 5.1 × 5.1 inches (13 × 13 cm).

The Mariner's Compass quilt is 4.5 × 4.5 inches (11.5 × 11.5 cm).

The overall size of the dollhouse is 11.8 × 15.7 × 11.8 inches (30 × 40 × 30 cm). The attic is used for sleeping, and it doubles as a sewing room. The tote bag leaning against the wall on the right is 1.5 × 1.3 × 0.2 inches (4 × 3.5 × 0.7 cm). The little sewing case with a lid is 1.1 × 1.1 inches (3 × 3 cm).

Shichi-Go-San

When Japanese girls reach the age of *shichi* (seven) and *san* (three), and boys reach the age of *go* (five), it is customary to dress the children in kimonos and visit shrines and have a big celebration. On the right here is a kimono for a seven-year-old girl. On the left is the mother's kimono. The matching handbags and shoes are incredibly tiny, yet they are so realistic they could be mistaken for the real thing. The mother's kimono is 5.9 inches (15 cm) and the girl's kimono 4.7 inches (12 cm).

It has long been said that the back of a kimono is beautiful, and the *obi* is the distinguishing factor. This girl's *obi* is a red flower pattern tied like a bow, and the mother's *obi* is a luxurious gold color. *Photos by Yuko Fukui*

Hina Matsuri Dollhouse

This box-shape dollhouse can be decorated according to any season. The theme that Hiroko has chosen this time is Hina Matsuri. She has also included a mini quilt hanging on the wall that features two *hina* dolls, and in the foreground there are traditional items for celebrating this important holiday.

The table is covered with a red cloth and there are miniatures of traditional flower arrangements: *sakura* (cherry blossoms) on the right side and *tachibana* blossoms on the left. Traditional diamond-shaped mochi sweets are also featured, along with sakura mochi, which is wrapped in a cherry blossom leaf.

The pale-pink cherry blossom–patterned kimono with a crepe *obi* is perfect for spring. The walls are also decorated with peach blossoms, which are believed to ward off evil spirits. On the shelf, there are two mandarin ducks, which bring happiness. Sitting next to the kimono is a small toy called *denden taiko*, which is a symbol of growth. All the miniature things here offer just a small representation of Japanese legends.

This indigo-dyed cotton *yukata* (type of summer kimono) matches well with the summer decor. Hiroko has included *yukata* fans, *geta* (sandals with a wooden base), and *noren* (curtains), all made in her signature elaborate technique. The *yukata* is 5.9 in. (15 cm). The box is 8.6 × 8.6 × 1.9 in. (20 × 20 × 5 cm).

Boy's Festival day is May 5. This box is a celebration of that special national holiday. Hiroko has decorated this dollhouse with a helmet, bow, arrow, sword, carp streamers, irises, and kashiwa mochi (*on the left*), all of which are traditional celebratory items. The carp streamer wall hanging is 5.9 × 2.7 in. (15 × 7 cm).

Part Three
Kawaii Projects

Journey to Japan with these tiny projects. Minis, appliqué, darling houses, even tiny *yukata* outfits are at your fingertips here. The instructions will guide you deep inside Japan's cherished kawaii culture.

Kawaii Minis in Red

BY AKI SAKAI

AKI SAKAI IS KNOWN for charming quilts created with carefully curated palettes. Her little red mini quilts are the perfect way to capture the essence of kawaii.

Materials

For the 4 smaller quilts:
 fabric for appliqué, lace pieces, and yo-yos
 fabric for the top, 15 × 15 cm (6 × 6 in.)
 fabric backing and batting, each 20 × 20 cm (8 × 8 in.)
 binding as desired
 decorative yarn
 red and white embroidery floss

For Hearts & Flowers:
 tiny white beads
 white pearl cotton

For Flowers:
 2 lace motifs, each 1 cm (0.4 in.) diameter
 tiny red beads

For Flowers & Shells:
 1 lace motif, 1 cm (0.4 in.) diameter
 tiny red beads
 tiny white beads
 cotton stuffing

For Summer:
 white pearl cotton
 cotton stuffing

For the Larger Mini:
 fabric for piecing and appliqué
 batting and backing, each 20 × 20 cm (8 × 8 in.)
 bias tape, 3.5 cm (1.4 in.) width: 65 cm (26 in.)
 tiny red beads
 1 lace motif, 1 cm (0.4 in.) diameter
 decorative yarn
 red and white embroidery floss

Kawaii Minis in Red

Larger Mini
Finished size: 13.4 x 13.4 cm (5.2 x 5.2 in.)

Flowers

Hearts & Flowers

Flowers & Shells

Summer

Finished size: 8.4 x 8.4 cm (3.3 x 3.3 in.) each

General Instructions

Appliqué and embroider as directed. Prepare the yo-yos and stuffed pieces and sew them on the top. Sew on the beads. For the Larger Mini, piece the patches together and embroider or sew decorative yarns along the seams. Place the batting and backing under the top and quilt as desired. Sew the binding and then hand sew a decorative yarn along the inside edge of the binding.

Tips

• Embroider with outline or back stitches around the appliqué and stuffed appliqué.

• When making the 3-dimensional motifs (marked with ☆ in the diagrams), make the opening about 1–1.5 cm (0.4–0.6 in.); choose the most suitable place based on the motif shape.

• For the embroidery use 1 strand except where otherwise specified.

Hearts & Flowers

The areas with ☆ marks are stuffed appliqué.

0.8 cm (0.3 in.) width binding

Embroider with outline stitches around appliqué and stuffed appliqué.

outline stitch

couching stitch

appliqué

Quilt as desired.

Sew tiny beads.

Sew fancy yarns.

8.4 cm (3.3 in.)

8.4 cm (3.3 in.)

Create the pattern with outline stitch and fill inside with chain stitches.

Sew beads in the yo-yo center.

bead

yo-yo

See page 171 for appliqué patterns.

Flowers

The areas with ☆ marks are stuffed appliqué.

yo-yo with tiny beads

back stitch

tiny beads

a
b
b
c
d

lace pieces

For the petals, appliqué with cotton fill inside.

Create the pattern with outline stitches and fill inside with chain stitches.

outline stitch

Hearts & Flowers

The areas with ☆ marks are stuffed appliqué.

yo-yo with tiny beads

Couching stitch (Suggest pearl cotton mixed with 1 strand embroidery floss)

outline stitch

e
f
g
f'
i
h

tiny beads

Create the pattern with outline stitches and fill inside with chain stitches.

Flowers & Shells

The areas with ☆ marks are stuffed appliqué.

Use bullion stitches for flower center (pearl cotton).

outline stitch

back stitch

j
k
l

Shells are stuffed with cotton.

Create the pattern with outline stitches (1 strand embroidery floss) and fill the inside with leaf stitches using pearl cotton.

Summer

The areas with ☆ marks are stuffed appliqué.

Create the pattern with outline stitches and fill inside with chain stitches.

Create the oval shapes with outline stitches and fill the inside with straight stitches.

outline stitch

Lace motif with tiny beads

m
n
o

outline stitch

back stitch (1 strand embroidery floss)

lace pieces

p
q
r
s

straight stitch

Create the fish pattern with outline stitches and fill inside with straight stitches.

outline stitch

Larger Mini

Sew decorative yarn on the seams.

outline stitch

chain stitch

0.8 cm (0.3 in.) width binding

Sew decorative yarn.

Quilt as desired.

Embroider with outline stitches around appliqué.

0.5 (0.2")

tiny beads

Quilt as desired.

13.4 cm (5.2 in.)

lace motif

Quilt as desired.

13.4 cm (5.2 in.)

Embroider with lazy daisy stitches and French knots on the seams.

outline stitch

Sew decorative yarn on the seams.

E

F

A

C

B

D

Instructions

Appliqué and embroider on each piece. → To make the top, sew pieces in sequence (A through F). → Put batting and backing under the top and quilt. → Sew on beads. → Sew fancy yarns or embroider on the seams. → Bind as desired with bias tape and sew fancy yarns on the edges.

Tips

• Embroider with outline or back stitches around the appliqué and 3-dimensional motifs.

• For the embroidery use 1 strand except when otherwise noted.

= appliqué

outline stitch

straight stitch

outline stitch

French knot

chain stitch

outline stitch

outline stitch

straight stitch

back stitch

back stitch

outline stitch

outline stitch (2 strands embroidery floss)

lazy daisy stitch

French knot

outline stitch

straight stitch

outline stitch

tiny beads

outline stitch

F

E

A

B

C

D

How to Make the Stuffed Appliqué

Only the one sail is 3-dimensional.

Embroider around the sails to make them stand out.

1
appliqué position

background fabric (RS)

appliqué motif fabric

Front and back fabric for the stuffed appliqué and batting. Add 0.5 cm (0.2 in.) seam allowance.

2
background fabric (RS)

Appliqué the left sail and boat. Whip stitch, needle turn the seam allowance.

3
top
front fabric (WS)
bottom
back fabric (RS)
sew
batting
opening

Put the front and back appliqué pieces together, right sides facing. Lay the batting underneath. Sew around the appliqué shape and leave a small opening.

4
tweezers
3-dimensional motif (RS)

Trim the batting close to the stitching. Using tweezers, turn the appliqué inside out and stuff the batting and the seam allowances inside. Stitch the opening closed.

5
Sew only one side of the sail.
3-dimensional motif (RS)
background fabric (RS)

Sew only one side of the stuffed sail appliqué to the background. Decorate as desired.

Appliqué Patterns Add 0.3 cm (0.1 in.) seam allowance.

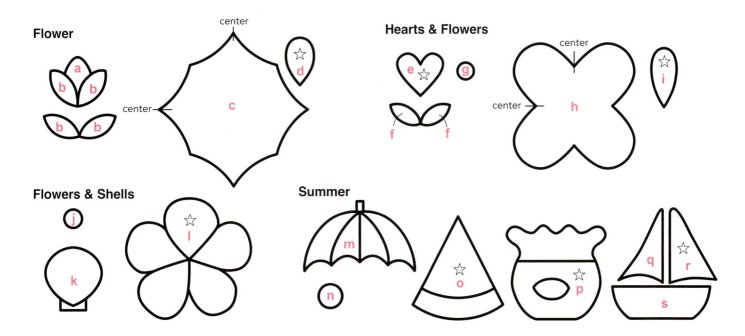

Flower
a
b b
b b
center
c
center
☆ d

Hearts & Flowers
e ☆ g
f f
center
h
☆ i

Flowers & Shells
j
k
☆
l

Summer
m
n
☆
o
☆
p
q ☆ r
s

Finished size: 95 x 50 cm (35.4 x 19.6 in.)

Summer Girl

BY AKIKO YOSHIMIZU

HER LARGE QUILTS typically feature thousands of tiny girls, each one so fashionably dressed that she looks like a movie star. Now, Akiko Yoshimizu brings her signature appliqué girls to a small wall hanging that will become the perfect kawaii showcase.

Materials

fabric for background blocks, appliqué, and yo-yos

batting and backing fabric, each 60 × 110 cm (24 × 44 in.)

bias tape, 6 cm (2.4 in.) wide; 295 cm (3.2 yd.), for binding

various colors of embroidery floss

General Instructions

Make 100 blocks with the finished appliqué. Piece the blocks together. Put batting and backing under the top. Quilt as desired. Bind. Add yo-yos around the outer edge.

Tips

- Feel free to change the orientation of the legs and arms to create different poses. For example, you can cross the legs or the arms on some of the girls. You can also change the shape or length of the bodices, skirts, and purses, and create different hair styles to make each girl slightly different.

- A basic pattern is provided on the next page. You can also create your own pattern to construct some of the girls from the back.

- Bind as desired.

Summer Girl

Basic Pattern

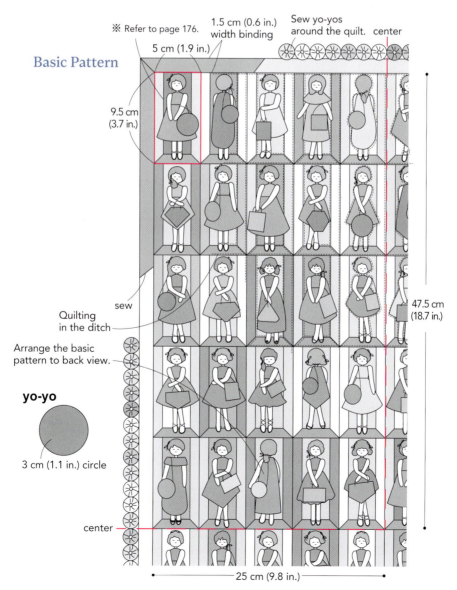

※ Refer to page 176.

5 cm (1.9 in.)

1.5 cm (0.6 in.) width binding

Sew yo-yos around the quilt. center

9.5 cm (3.7 in.)

47.5 cm (18.7 in.)

sew

Quilting in the ditch

Arrange the basic pattern to back view.

yo-yo

3 cm (1.1 in.) circle

center

25 cm (9.8 in.)

▶ The Basic Pattern Diagram

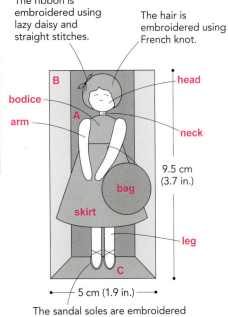

The ribbon is embroidered using lazy daisy and straight stitches.

The hair is embroidered using French knot.

head

bodice

arm

B

A

neck

bag

skirt

C

9.5 cm
(3.7 in.)

leg

5 cm (1.9 in.)

The sandal soles are embroidered with outline stitches.

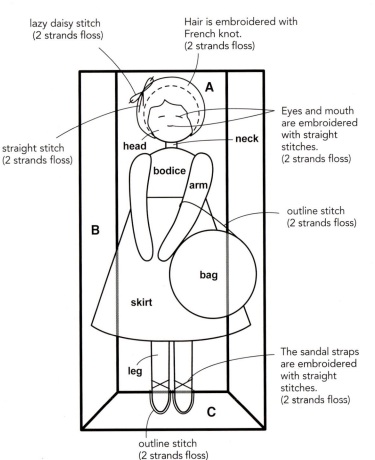

lazy daisy stitch
(2 strands floss)

Hair is embroidered with French knot.
(2 strands floss)

straight stitch
(2 strands floss)

head

neck

bodice

arm

Eyes and mouth are embroidered with straight stitches.
(2 strands floss)

outline stitch
(2 strands floss)

B

bag

skirt

leg

C

The sandal straps are embroidered with straight stitches.
(2 strands floss)

outline stitch
(2 strands floss)

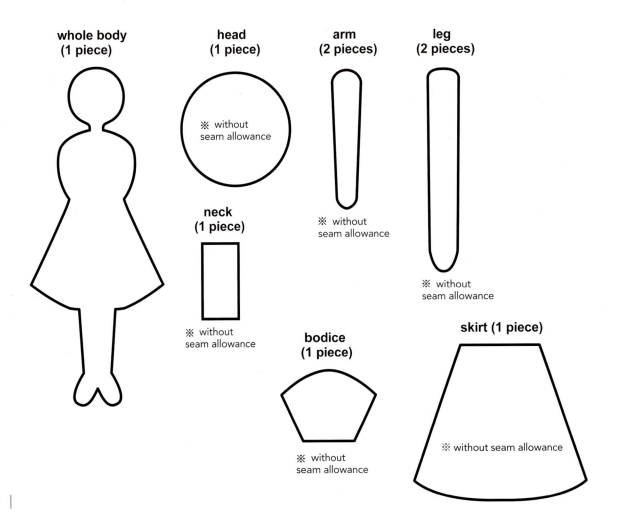

**whole body
(1 piece)**

**head
(1 piece)**

※ without
seam allowance

**neck
(1 piece)**

※ without
seam allowance

**arm
(2 pieces)**

※ without
seam allowance

**leg
(2 pieces)**

※ without
seam allowance

**bodice
(1 piece)**

※ without
seam allowance

skirt (1 piece)

※ without seam allowance

Doll Appliqué

Add the details with embroidery.

Remember: Vary the shapes as desired to make different designs.

1

background fabric (RS)

appliqué position

Place the pattern pieces on the background and mark the position of each piece.

2

2. head Pull the thread

1. neck (RS)

0.3 cm (0.1")

3. leg Sew and pull the thread

Construct the head, neck, arms, and legs. For curves and points, baste the seams with tiny stitches and gather the threads to hold the seams in place. The neck fabric can be folded twice to create depth and hide the seams.

3

4. bodice

5. skirt

Cut the bodice and skirt with the basic pattern and appliqué. Change the shape of the skirt by making it long, short, or wide, etc.

4

6. arm

Sew and pull the thread

Cut the arms with the basic pattern. Position them into place and appliqué.

5

French knot

Eyes and mouth are embroidered with straight stitches.

Make the bag as you like.

straight stitches

Outline stitch the sandal soles.

The photos here demonstrate how to construct the girl on an oval background. Follow the instructions for a rectangle background as shown on page 176.

Darling Mini Houses

BY REIKO KATO

DRESS UP YOUR STUDIO or your home with these precious three-dimensional quilted houses and baskets. These projects are completely representative of Reiko Kato's kawaii style. Make one for yourself, and one for a friend.

Materials

Box
 fabric for piecing and appliqué and the bottom, 10 × 10 cm (4 × 4 in.)
 backing for the sides (including bottom backing), 35 × 15 cm (14 × 6 in.)
 roof background fabric (including the roof and background backing), 20 × 15 cm (8 × 6 in.)
 batting and backing, each 50 × 20 cm (20 × 8 in.)
 single fusible batting and bottom board, each 15 × 15 cm (6 × 6 in.)
 bias tape, 3.5 cm (1.4 in.) width; 30 cm (12 in.), for piping
 plastic board, 0.2 cm (0.08 in.) thick, 20 × 25 cm (8 × 10 in.)
 Velcro, embroidery floss, and pearl cotton

Pincushion
 fabric for appliqué
 bottom fabric (including A), 20 × 10 cm (8 × 4 in.)
 side background fabric, 20 × 10 cm (8 × 4 in.)
 batting and backing, each 25 × 10 cm (10 × 4 in.)
 felt ball, 4 cm (1.6 in.) diameter

Basket
 fabric for piecing and appliqué
 3 different prints for the sides, each 20 × 10 cm (8 × 4 in.)
 background and backing for the pocket, and batting, each 40 × 20 cm (16 × 8 in.)
 backing and back fabric, each 55 × 20 cm (22 × 8 in.)
 single fusible batting
 plastic board or sturdy cardboard, 0.2 cm (0.08 in.) thick, 15 × 15 cm (6 × 6 in.)
 6 kinds of 3 cm (1.2 in.) width bias tape for piping, each 10 cm (3.9 in.)
 4 kinds of 2.8 cm (1.1 in.) width bias tape for the handle, each 25 cm (9.8 in.)

Darling Mini Houses

Box
Finished size: 6.5 × 7.5 × 9.5 cm
(2.5 × 2.9 × 3.7 in.)

Pincushion
Finished size:
4 cm dia.,
4.8 cm h
(1.5 in. dia.,
1.8 in. h)

Basket
Finished size:
9.5 × 11 × 8.2 cm
(3.7 × 4.6 × 3.2 in.)

Box

Tip
The sides might shrink a bit in shape after sewing, so you may need to adjust the bottom piece to make it fit. Cut the bottom board smaller than the adjusted size.

side (1 piece)
Outline stitch using 2 strands of embroidery floss around the shapes.

Quilt as desired.

Velcro position (loop side)

Velcro position (loop side)

8.8 cm (3.4 in.)

side A

side B

side A

side B

24 cm (9.4 in.)

※ Backing is one piece of the same size.

roof (1 piece)
hexagon

blanket stitch (pearl cotton)

A

6.2 cm (2.4 in.)

fold-line

center

6.4 cm (2.5 in.)

roof background (1 piece)
1 cm (0.5 in.)

fastener position

5.75 cm (2.2 in.)

fold-line

6.3 cm (2.4 in.)

※ For the backing, cut on the fold-line and prepare 2 pieces.

roof backing (2 pieces)
※ without seam allowance

8 cm (3.1 in.)

3 cm (1.1 in.) opening

8 cm (3.1 in.)

※ Sew the 2 pieces except the opening and open the seam allowance.

bottom (1 piece)
1.2 cm (0.5 in.) 1.2 (0.5 in.)

5.5 cm (2.1 in.)

6.5 cm (2.5 in.)

※ Lining fabric same size

side A board (2 pieces)
8.4 cm (3.3 in.)

6.1 cm (2.4")

side B board (2 pieces)
5.6 cm (2.2 in.)

5.1 cm (2.2")

bottom board (1 piece)
5.1 cm (2 in.)

6.1 cm (2.4")

roof background board (2 pieces)
5.5 cm (2.1 in.)

6 cm (2.3 in.)

▶ How to Make the Side

1 top (RS) / batting / backing (WS) / 1 / 3 / 2

1 Piece and appliqué to make the top.
2 Quilt it.
3 Outline stitch around the windows.

2 side (RS) / 1 / 3 / 2 / 0.7 cm (0.2 in.) / backing (WS)

1 Put the side and backing right sides together.
2 Sew except the bottom.
3 Clip the seam allowances here to allow the house to fold.

3 side (RS) / 1 / 3 / side A board / side B board / side A board / side B board / 2

1 Turn it over and machine stitch next to the seam.
2 Insert the boards to the sides and baste them.

4 side (RS) / 1 / 2

1 Assemble the house and whip stitch the remaining side closed.
2 Trim the seam allowances, but do not cut the basting stitches.

▶ How to Make the Roof

1 top (WS) / backing (RS) / batting / 2 / 1 / 3 / 4 / 0.5 cm (0.1 in.)

1 Sew 2 pieces of backing except the opening.
2 Put the top and backing right side together. Lay the batting under the backing and sew around.
3 Cut the seam allowance even. Cut the batting next to the seam.
4 Snip the seam allowance into inside points.

2 backing (RS) / 1 / 3 / 2

1 Cut the batting along the backing opening and turn it inside out.
2 Whip stitch the opening.
3 Blanket stitch around the outside edges of the entire roof.

3 roof back-ground (RS) / opening / 1 / 2 / roof background backing (WS)

1 Fold the backing seam allowance to back and put the pieces together.
2 Put the background and backing right side together and sew around.

4 roof back-ground board / 1 / 3 / 2 / roof background backing (RS)

1 Turn inside out.
2 Insert the boards from the opening.
3 Sew the opening closed.

5 roof back-ground (WS) / roof (WS) / 1 / 2 / fastener (WS)

1 Place the roof and back-ground pieces together and align them from the center.
2 Sew the Velcro in place.

▶ How to Make the Bottom

batting / top (RS) / 1 / backing (RS) / board / 2 / back fabric (RS)

1 Put the 3 layers together and quilt.
2 Lay the board and back fabric right side out and baste.

▶ How to Assemble

1 side (RS) / 1 / 2 / bottom (RS)

1 Put the side and bottom right side out.
2 Sew them.

2 1 cm (0.4 in.) dia. Velcro / 2 / 1 / 0.8 cm (0.3 in.)

3 roof (RS) / side (RS) / ※ side A

1 Finish the bottom seam allowance with a bias tape.
2 Sew the Velcro.
3 Sew the roof center to the top of side A.

side B

Velcro position

side A

side A board (2 pieces)

Velcro position

side B

side A

piece A

| 181

Pincushion

Tip

Prepare the pincushion insert as desired. This example uses a ball made from felted wool. Make sure the finished pincushion insert is the correct size.

side (1 piece)

quilting

4.8 cm (1.8 in.)

Quilt in the ditch

opening

A

13 cm (5.1 in.)

bottom (1 piece)

1.7 cm (0.6 in.)

1.7 cm (0.6 in.)

4 cm (1.5 in.) dia.

bottom backing (2 pieces)

4 cm (1.5 in.)

2 cm (0.7 in.) opening

2 cm (0.7 in.)

▶ How to Make the Bottom

① backing (WS)

top (RS)

opening

batting

1 Stitch the 2 backing pieces together. Leave a small opening. Put the top and backing right
2 sides together, lay the batting under them, and sew.

② backing (RS)

1 Trim the batting close to the seam. Turn inside out.
2 Whip stitch the opening and quilt it from the top.

▶ How to Assemble

①

side background (RS)

point to stop sewing

Don't whip stitch outside the pattern mark.

6.5 cm (2.5 in.)

15.5 cm (6.1 in.)

finish line

1 Appliqué on the side background.
2 Baste it.

②

background (RS) batting 0.5 cm (0.2 in.)

backing (WS)

opening

1 Lay the batting under the background.
2 Put the backing right sides together and sew except the opening.
3 Cut around with 0.5 cm (0.2 in.) seam allowance and snip the seam allowance into inside points.

③

side (RS)

1 Cut the batting next to the seam. Turn it inside out and whip stitch the opening.
2 Quilt it.

④

side (WS)

bottom (WS)

1 Put the sides right sides together and whip stitch.
2 Put the sides and bottom right sides together and whip stitch.

⑤

felt ball

body (RS)

1 Turn it inside out.
2 Put the felt ball inside.

quilting

A **side (1 piece)**

opening

bottom (1 piece)

Basket

Tips

- Prepare 6 pockets. Make each one using a different print. Refer to the templates for details.
- The pocket size may shift slightly after sewing. Adjust the sizes as needed.
- Cut the bottom board slightly smaller than the opening.
- Stitch the sides together in sequence, A through F.

pocket (6 pieces)
Quilt in the ditch
7 cm (2.7 in.)
7 cm (2.7 in.)
5.5 cm (2.1")
The illustration is pocket A.

bottom (1 piece)
5.5
9.5 cm (3.7 in.)
quilting at 1.5 cm (0.6 in.) space
11 cm (4.3")
8.2 cm (3.2 in.)
※ Backing is the same size.
※ Prepare the board 0.2 cm (0.08") smaller.

side fabric (6 pieces)
pocket position
5.5 cm (2.1")
※ Fuse the same size fusible interfacing on the back.
※ Cut 2 pieces for each pocket background block using three different prints for the 6 sides.
※ Side backing is the same size.

▶ How to Make the Pockets

❶ Leave the top seams open.
7.5 cm (2.5 in.)
7 cm (2.7 in.)
pocket fabric (RS)
finish line

1 Appliqué on the pocket fabric.
2 Sew the bottom piece.
3 Baste around.

❷ pocket fabric (RS) batting
0.7 cm (0.2 in.)
backing (WS)

1 Lay the batting under the pocket fabric.
2 Put the backing right sides together and back stitch.
3 Cut the upper side with 0.7 cm (0.2 in.) seam allowance and snip into the inside points.

❸ pocket (RS)
0.5 cm (0.1 in.)

1 Turn inside out.
2 Quilt it.
※ Make pockets B through F in the same way.

▶ How to Make the Sides

❶ side fabric (RS)
pocket (RS)
side backing (WS)

1 Place the decorated pocket on the background block with right sides together.
2 Place the backing behind the background block and stitch around the edge. Leave the top section open.

❷ 0.8 cm (0.3 in.)
bias tape for piping (RS)
side (RS)

1 Turn it inside out.
2 Finish the seam allowance with bias tape.

❸ side (WS)

1 Make the other sides in the same way as ❶ - ❷.
2 Put the sides right sides together and whip stitch to make a tube.

▶ How to Make the Handle

❶ 22 cm (8.6 in.) bias tape for the handle (WS)
0.5 cm (0.1 in.)
sew

Fold the tape in half and sew along the seam, forming a tube.

❷ batting

1 Turn the handle inside out.
2 Cut the batting strip to fit and insert it into the handle.
3 Stitch both ends of the handle closed.

❸ 1.5 cm (0.5 in.) 15 cm (5.9 in.) 1.5 cm (0.5 in.)

1 Make 4 stuffed tubes for the handle. Braid the tubes together and use thread to temporarily hold them in place.

▶ How to Make the Bottom

❶ backing (WS) finish line
top (RS)
single fusible batting

1 Fuse the batting on the wrong side of the top fabric.
2 Place the backing and quilt.
3 Fold the seam allowance toward the backing.

❷ bottom backing (RS)
plastic board
bottom (RS)

1 Fold the backing seam allowance to back.
2 Put the bottom and backing right side out.

▶ How to Assemble

bottom (WS)
side (WS)
basket (RS)

1 Put the side and bottom right side together and whip stitch.
2 Turn inside out.
3 Sew the handle on the basket.

quilting

pocket A (1 piece)

quilting

pocket B (1 piece)

quilting

pocket C (1 piece)

quilting

pocket D (1 piece)

quilting

pocket E (1 piece)

quilting

pocket F (1 piece)

board for the bottom (1 piece)

bottom (1 piece)

Kawaii Summer Fashion

BY HIROKO AKITA

JUMP RIGHT IN to make this quilt so small that it'll fit in the palm of your hand. Next, try making Hiroko Akita's tiny his and her outfits: a yukata for her (a type of summer kimono made with cotton fabric), plus a tiny shirt and pants for him. Assemble your very own kawaii doll house.

Materials

Yukata and obi
- body fabric, 30 × 35 cm (12 × 14 in.)
- cotton tape, 0.9 cm (0.4 in.) width, 40 cm (16 in.)
- fabric for obi (including bow A and B), 30 × 10 cm (12 × 4 in.)
- thick fusible interfacing for obi, 15 × 5 cm (6 ×2 in.)
- 2 sets of tiny snaps, 0.7 cm (0.3 in.)
- thick paper or interfacing for the obi (bow)

Body and stand (each)
- felt, 15 × 10 cm (6 × 4 in.)
- dowel, 0.5 cm (0.2 in.) diameter;
 - *For her*: 12 cm (4.7 in.) long *For him*: 13 cm (5.1 in.) long
- wood circle, 5 cm (2 in.) diameter, 1 cm (0.4 in.) thick
- cotton fill and batting

Shirt
- fabric for body, 55 × 15 cm (22 × 6 in.)
- fusible interfacing, 5 × 5 cm (2 × 2 in.)
- 3 buttons, 0.5 cm (0.2 in.) diameter

Pants
- fabric for pants, 25 × 15 cm (10 × 6 in.)
- yellow-brown pearl cottonn

Miniature Quilt
- fabric for piecing
- fabric for pieces F, G, H, I, K, L (including fabric for finishing seam allowances), 70 × 20 cm (28 × 8 in.)
- batting and backing, each 15 ×15 cm (6 × 6 in.)

Kawaii Summer Fashions

D Miniature Quilt

B Shirt

A Yukata

C Pants

Finished sizes:
A. 14 cm (5.5 in.) length
B. 7 cm (2.7 in.) length
C. 13 cm (5.1 in.) length
D. 12.5 × 12.5 cm (4.9 × 4.9 in.)

A Yukata

Yukata back view
showing the obi (bow)

Back style

Mariner's Compass Miniature Quilt
made with yukata fabric

D Miniature Quilt

A Yukata

Tips

- Refer to the templates for details.
- Allow a 1 cm (0.4 in.) seam allowance except for the obi, bow, and body.

General Instructions

1 Sew the front bodice and front panel together. Do this for both sides.

2 Put the front and back bodice right side together and sew from mark to mark on the shoulder line.

3 Sew the sleeves on the bodice.

4 Put the front and back bodice right sides together, sew from the side opening to the bottom, and open the seam allowances.

5 Sew the collar on the body.

6 Turn it inside out. Fold the bottom seam allowance to the back and stitch it in place using a tiny zig-zag stitch.

7 Attach two bias tapes on both sides inside the collar as shown, about 7 inches each.

8 Construct the mannequin. Place the yukata on the mannequin.

9 Make the obi and bow and add them to the yukata.

▶ How to Make

1

back bodice (RS)

shoulder line

sleeve (WS)

sleeve (RS)

sleeve cap

sleeve position

front bodice (RS)

front bodice (RS)

small front panel (RS)

1 Place the sleeve aligned with the shoulder line on the bodice, right sides together. Stitch according to the marks shown.

2 Turn the sleeve and bodice inside out. Press the seam allowance toward the sleeve.

2

sleeve cap

back bodice (WS)

sleeve opening

sleeve (WS)

Avoid the bodice.

Running stitch with double thread

1 Fold the sleeve in half at the shoulder line.

2 Stitch along the edges as marked, leaving an opening at the top for the arm hole.

3 Stitch a row of basting stitches in the curve seam as shown.

3

back bodice (WS)

sleeve opening

sleeve (WS)

1 Gather the basting stitches in the curve and manipulate the curve until it is smooth.

2 At the arm hole, press the seam allowance toward the back.

3 Other seam allowances can be pressed open.

▶ How to Add the Collar

1

sleeve (WS)

collar (WS)

collar fold-line

bodice (RS)

collar fold-line

Avoid the seam allowance

1 Place the collar along the bodice, right sides together.

2 Sew from mark to mark as shown.

2 Snip the collar seam allowance of the back bodice, fold it inside, and whip stitch.

bodice (WS)

1 Fold the collar over toward the inside of the yukata. Make sure to cover the seams.

2 Stitch the collar in place so that the stitches do not show on the outside.

▶ How to Place the Yukata on the Mannequin

①

body

2

1

3

1 Glue a tiny piece of batting on the mannequin body in the bust area to add shape.
2 Put the yukata on the mannequin.
3 Pass the right sash through the side opening.

②

1

3

2

about
6.5 cm
(2.5 in.)

Cut vertically.

toilet paper tube

1 Bring the left sash from back to front.
2 Bring the side sash from back to front and tie the sashes in a square knot.
3 Insert the toilet paper tube inside the yukata with the slit toward the back. This will help the tiny garment keep its shape.

**yukata collar
(1 piece)**

**yukata front bodice
(symmetrical pieces, 1 each)**

front bodice
position

center

front bodice
position

★ ★

sleeve
position

sleeve
position

sleeve
position

**yukata sleeve
(symmetrical
pieces, 1 each)**

★

center

★

side opening

side opening

side opening

sleeve
opening

sleeve cap

Sew together.

sleeve
cap

sleeve
position

sleeve
opening

yukata back bodice (1 piece)

**small
front
panel**

◆

▶ How to Make the Obi

1

fusible interfacing 1

obi front (RS)

2

1 Fuse the interfacing on the wrong side of the obi.
2 Fold the seams inward.

2

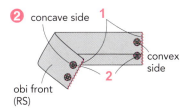

concave side 1

convex side

obi front (RS)

2

1 Stitch the ends closed.
2 Attach the tiny snaps as shown.

▶ How to Make the Bow

1

fold-line

bow A (WR)

1 cm (0.3 in.)

opening

Fold the fabric in half, right side together, and sew. Leave an opening as marked.

2

2

bow A (RS)

1

3

1 Turn the bow inside out. Baste across the center using double thread.
2 Gather the threads across the center to form the bow shape.
3 Secure at the back with a knot.

3

bow B (RS)

fold-line 2

1

bow B (RS)

1 Make an interfacing using thick paper. Fold the top and bottom raw edges toward the center line as shown, then fold in half again. Glue the insides together to hold it in place.

4

bow A (RS)

fold-line 1

2

thick paper bow B (RS)

1 Place this strip over the center of the gathered stitches on the bow and
2 stitch it in place. Be sure to leave the ends open as shown. Glue the two ends together.

5

bow A (RS)

back

2

bow B (RS)

1

4

3

obi front (RS)

1 Place a line of glue on the front of the strip.
2 Wrap the obi around the yukata with the seam along the sides.
3 Insert the strip holding the bow inside the obi. Hand press to hold the strip in place until the glue is firm.

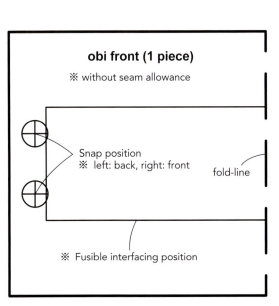

obi front (1 piece)

※ without seam allowance

Snap position
※ left: back, right: front

fold-line

※ Fusible interfacing position

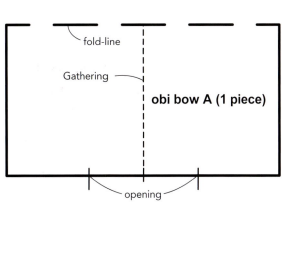

fold-line

Gathering

obi bow A (1 piece)

opening

obi bow B (1 piece)

※ without seam allowance

▶ How to Make the Body

1

body (WS)

body (RS)

1

2

opening

1 Place the two pieces of the body together,
2 wrong sides together. Stitch around the sides leaving the bottom open as marked.

2

3

body (RS)

2

7 (2.7")

cotton

dowel

round wood piece

1

1 Insert the dowel in the hole of the round base and glue to secure.
2 Insert the dowel in the body.
3 Stuff the body form with cotton and stitch the bottom closed on either side of the dowel.

3

batting

1 cm (0.3 in.)

3 cm (1.1")

body (RS)

Paste batting on the bust position.
※ For the Miniature Shirt and Pants, don't paste batting.

center

body for yukata (2 pieces)

※ without seam allowance

Stuff the cotton through this opening.

stick position

▶ How to Make the Shirt

1 Sew the shoulder lines of front and back bodice.
2 Make the collar.
3 Put the collar on the bodice right sides together, sew, and snip the seam allowance.
4 Sew the sleeves on the bodice.
5 Fold the cuff seam allowance to back.
6 Sew the front and back facing.
7 Fold the front facing on the fold-line, right sides together, and sew the collar, bodice, and facing together.
8 Sew the hem of the front facing and turn it inside out.
9 Put the front and back bodice right sides together and sew from the under sleeve to side.
10 Turn it inside out, fold the hem seam allowance to back, and zig-zag.
11 Put the shirt on the body and add buttons.

back facing

collar

7

2

6

1

4

sleeve

front bodice

front facing

back bodice

8

10

9

11

B Shirt

C Pants

▶ How to Make the Collar

(RS) 1
finish line 2
(WS) 3 (RS)

1 Put the 2 pieces right sides together and sew.
2 Turn it inside out.
3 Snip the inside curve seam so the collar will lay flat. Be careful not to cut into the line where you will stitch.

end of the collar 6 back facing (WS)
facing fold-line end of the collar 1 facing fold-line
collar (RS) 4
front bodice (WS) sleeve (WS) back bodice (WS) sleeve (WS) front bodice (WS)
5 3

facing fold-line 7 facing fold-line
sleeve (RS) back facing (WS) sleeve (RS) 8
front bodice (RS) back bodice (RS) front bodice (RS)

Tips

• Templates include seam allowances.

• Refer to the "How to Make the Body" instructions found in the yukata pattern, but do not insert the stand inside the pants.

Make a small basting stitch around the top. Leave long tails of thread in place to gather later.

back 5
front 4
1
opening for the dowel
0.3 cm (0.1 in.)
4 0.3 cm (0.1 in.)
0.2 cm (0.07 in.) 2 3
4
0.2 cm (0.07 in.)

▶ How to Make the Pants

1 Place the two pieces of the pant leg wrong sides together. Stitch the front and back rise. Leave an opening for the dowel as noted.
2 Press the seam allowance to the back.
3 Align the inseam of the two legs right sides together and stitch.
4 Turn the pants inside out. Stitch along the sides and the hem.
5 Fold the waist seam allowance to the inside and stitch it down. Leave the gathering stitches in
6 place.
Insert the mannequin body (without the stand) so
7 that the dowel goes through the crotch opening.
Pull the gathering threads around the waist to
8 tighten the pants. Knot the threads inside.
Insert the dowel into the stand.

shirt front bodice
(symmetrical pieces, 1 each)

front facing

fold-line

end of the collar

button (left bodice only)

snipping

cutting line

shirt collar (2 pieces)

snip

bodice position

shirt back facing (1 piece)

cutting line

snip

※ fusible interfacing without seam allowance

cutting line

shirt back bodice (1 piece)

cutting line

snipping

dowel position

shirt body (2 pieces)
※ without seam allowance

opening to stuff cotton

center

shirt sleeve (2 pieces)

cutting line

sleeve cap

cutting line

pants (symmetrical pieces, 1 each)

dowel opening

back

front

D Miniature Quilt

Instructions

Sew pieces of B through I. → Appliqué A in the center and make the Mariner's Compass pattern. → Sew J and K and add them on top and bottom of the pattern. → Sew the pieces of K through O and add to the right and left of the pattern to make the top. → Lay batting and backing under it and quilt. → Finish the edge seam allowance with the fabric.

Tips

- Cut pieces with 0.5 to 0.7 cm (0.2 in. to 0.3 in.) seam allowance and cut the seam allowance to 0.3 cm (0.1 in.) after sewing.
- After sewing the top, press the seam allowances to the same direction as much as possible.

finishing fabric (1 piece)

3 cm (1.1") ※ without seam allowance
67 cm (26.3 in.)

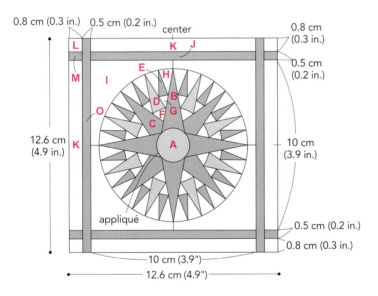

0.8 cm (0.3 in.) 0.5 cm (0.2 in.)
center
L K J
M
0.8 cm (0.3 in.)
0.5 cm (0.2 in.)
E
I H
D B
O F G
C
A
12.6 cm (4.9 in.) K
10 cm (3.9 in.)
appliqué
0.5 cm (0.2 in.)
0.8 cm (0.3 in.)
10 cm (3.9")
12.6 cm (4.9")

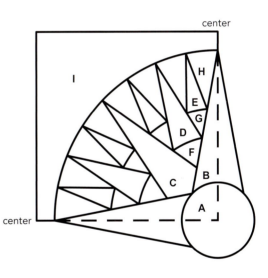

center
I
H
E
G
D
F
C
B
A
center

▶ How to Finish Seam Allowances

❶
1 finishing fabric
0.5 cm (0.2") (WS)
2
3
quilt (RS)

1 Put the finishing fabric on the quilt right sides together, sew from corner to corner, and secure a knot.
2 Snip the corner seam allowances.
3 Sew the next side in the same way.
 ※ Repeat 1-3.

❷ Fold fabric 0.5 cm (0.2 in.) inside.
finishing fabric (RS)
Fold in the corner.
1 quilt (WS)
2 cm (0.7")
2
0.3 cm (0.1 in.) finishing fabric (RS)
3
quilt (WS)

1 Cut the batting next to the seam and fold the seam allowance on the seam.
2 Flip the finishing fabric and whip stitch on the backing.

Cute Christmas Kokeshi Dolls

BY MEGUMI MIZUNO

BRING SOME JAPANESE STYLE to your Christmas decorations with these darling kokeshi dolls. Megumi Mizuno shows how these cheerful colors, precious faces, and one happy reindeer that jumps from doll to doll will brighten up your home with kawaii culture.

Materials

(for 1 doll)

fabric for appliqué

fabric for the body, gusset, bottom, and hat

batting and backing fabric, each 30 × 40 cm (12 × 16 in.)

white felt for the hat, 5 × 20 cm (2 × 8 in.)

2 mm thick plastic board or sturdy cardboard, 5 × 10 cm (2 × 4 in.)

felt ball and small bead, each 1.2 cm (0.5 in.) diameter

cotton and/or plastic pellets for stuffing

embroidery floss

Cute Christmas Kokeshi Dolls

Finished size: 10 cm (3.9 in.) high

front (1 piece)

hat position
quilting in the ditch
reverse appliqué
1.5 cm (0.6 in.)

10.5 cm (4.1 in.)

8.2 cm (3.2")

back (1 piece)

1.5 cm (0.6 in.)

10.5 cm (4.1 in.)

On the bottom add French knots freely.

8.2 cm (3.2")

※ symmetrical to the front

gusset (1 piece)

fold-line

12.25 cm (4.8 in.)

1 cm (0.3 in.)

On the bottom add French knots freely.

4 cm (1.5")

bottom (1 piece)

4 cm (1.5 in.)

6 cm (2.3 in.)

※ Cut with 1 cm (0.4 in.) seam allowance.
※ Bottom board is the same size.

▶ How to Make the Bottom

1 bottom board

2

1 Round the corners of the bottom stabilizing board.
2 Sew basting stitches around the outside edges of fabric.

bottom fabric (RS)

2

Gather the seams over the board and connect them to hold the seams in place as shown, or use glue.

gift bag fabric (2 pieces)

6.8 cm (2.6 in.)

4.6 cm (1.8 in.)

(RS)

1 **2** **3**

1 Put 2 pieces right sides together and sew the sides and bottom.
2 Cut the opening with pinking shears and turn right side out.
3 Fill with cotton and tie the opening with embroidery floss.

hat (1 piece)

center 1.5 cm (0.6 in.)

6 cm (2.3 in.)

opening

12 cm (4.7 in.)

hat trim (1 piece)

1.2 cm (0.4 in.)

16.5 cm (6.4 in.)

※ without seam allowance

▶ How to Make the Hat Trim

1 0.3 cm (0.1 in.)

Sew the upper side and pull the thread a little.

2

Put both ends together and whip stitch.

▶ How to Make the Hat

1

backing (RS) batting
top (WS)
opening

1 Place the front and back hat pieces right sides together. Place the batting under one side.
2 Stitch around the seams leaving a small opening.

2

top (RS)

1 Turn the hat inside out. Stitch the opening closed.
2 Quilt hat as desired.

3

bead
felt ball
top (RS)
hat bottom (RS)

1 Align the two edges of the hat and stitch using an overcast stitch.
2 Attach the felt hat trim to the hat and stitch in place.
3 Add the ball and beads.

RED front (1 piece)
※ Back is a symmetrical piece.

straight stitch
(2 strands embroidery floss)

hat position

center

outline stitch
(1 strand floss)

satin stitch
(1 strand floss)

satin stitch
(2 strands floss)

quilting

Fill in with
outline stitch
(2 strands floss)

outline stitch
(4 strands floss)

French knot
(4 strands floss)

satin stitch (2 strands floss)

BLUE front (1 piece)
※ Back is a symmetrical piece.

hat position

center

reverse appliqué

straight stitch
(2 strands floss)

satin stitch
(2 strands floss)

outline stitch
(1 strand floss)

satin stitch
(1 strand floss)

sequin

French knot
(4 strands floss)

hat (1 piece)

opening

gift bag (2 pieces)

▶ **How to Assemble**

1

backing
(WS)

top (RS)

batting

2

1

2

front (RS)

gusset (WS)

1

2

back (WS)

3

1

cotton

pellets

gusset (RS)

front (RS)

bottom (RS)

2

3

back (RS)

4

whip stitch

Blue

Red

sequin

Make the gift bag
and sew it on the front.

1 Appliqué and embroider to make
the front.
2 Lay the batting under it and quilt.
 ※ Make the back section and the
gusset using the same process.

1 Align the front, back, and
gusset right sides together.
2 Stitch the seams. Leave the
bottom open.

1 Turn it inside out. Stuff the inside with cotton
and/or pellets.
2 Construct the bottom piece and fold the seam
allowances over the interfacing board.
3 Attach the bottom to the body and stitch.

Hina Matsuri Festivals:
What to Know and Where to Go

Hina Matsuri is one of Japan's annual festivals that generations of families have celebrated for centuries, and it's a clear example of a source from which the traditions of kawaii and kawaii quilting have arrived to us. The centerpiece of the month-long celebration is the national Girl's Day holiday on March 3 (although some regions follow the lunar calendar and mark the holiday on April 3).

Hina Matsuri celebrations are held from early February through the beginning of April, and every local festival has its own distinctive flavor and dates. Many Japanese, especially women, enjoy traveling to the different regions and experiencing the festivities, tasting the specialty cuisine and darling treats, and mixing with locals who host the events. In addition, Hina Matsuri is also treasured and celebrated by families inside their homes.

At the regional events, homes, storefronts, hotels, even outdoor steps and streets are decorated for the season. There are two main types of displays that are common throughout Japan: the *hinadan*, which is a multi-tiered display of *hina* dolls that are seated and dressed in the finest costumes, and *tsurushi kazari*, which are colorful mobiles with dolls and figurines hanging on long strands of red cord. Both the *hina* dolls and the mobiles are steeped in history and tradition.

The seated *hina* dolls follow a strict order for which dolls are displayed on which tier, and the stand, or steps, must be covered in red cloth. At the top are the emperor and empress dolls. Below them are ladies of the court, musicians, servants, and attendants. Each doll is dressed in an elaborate costume, usually made from the finest silk. Tiny tea sets, lanterns, peach blossom branches, instruments, treats, and other small furniture pieces are placed alongside the dolls.

While the *hina* dolls are incredibly gorgeous and untouchable, the lively, colorful *tsurushi kazari* mobiles are the complete opposite. The small, stuffed ornaments on these vibrant displays were originally sewn from leftover silk kimono scraps, and as such, they have a quaint aura about them. Many foreign quilters find them charming. There are hundreds of different handmade characters—flowers, triangles representing Mt. Fuji, carrots and strawberries, bunnies and fish—and each region will showcase different figures to create eye-catching displays of color and shape.

The Izu region is considered the birthplace of *tsurushi kazari*. Historically, these hanging ornaments were created as a way to decorate for the season when common people could not afford the expensive *hina* dolls. *Tsurushi kazari* are made all over Japan, but there are several styles of characters—as well as mobile structures—that are unique to certain regions. For example, some mobile structures have tops that are shaped like umbrellas, others are open and circular, and others are made with a certain fabric or decorated a certain way. Red tassels are sometimes included to add to the flair.

In Sakata, Yamagata Prefecture, you'll find *kasa-fuku*, which translates as "happy umbrella." These tiny stuffed shapes and figurines hang from a red umbrella structure at the top. In Yanagawa, Fukuoka Prefecture, the local decorations feature *sagemon*,

Yanagawa
Fukuoka

Kyoto
Chimoto Restaurant

Sakata
Yamagata

Mizusawa
Oshu, Iwate

Makabe
Sakuragawa, Ibaragi

Inatori
Higashi-Izu, Shizuoka

Tokyo
Hotel Gajoen Tokyo

which are elaborate displays with seven sets of seven stuffed cranes, turtles, shrimp, and other figures, forty-nine in total, that dangle from red and white rings. Inside the mobile there are two highly decorated *temari* (hand-woven balls). The inclusion of exactly fifty-one ornaments dates back to a time when a lifespan of fifty years was uncommon and parents wanted to live an extra year, to the age of fifty-one years, to be with their children. Region-specific elements like these reflect each community's ways of making the national tradition their own.

If you plan to visit Japan in early February through early April, you can certainly find a local Hina Matsuri festival, and if you take the time to visit, you'll have the opportunity to experience a special holiday celebration and discover the origins of Japan's kawaii culture firsthand.

Here are our recommendations for the most memorable Hina Matsuri festivals in the country. The dates can change, so be sure to check details and timing in advance.

Tokyo: Hotel Gajoen Tokyo

▲ This gorgeous hotel hosts a lavish, annual display of *hina* dolls in seven stunning galleries. English descriptions are available on the information panels.

Hotel Gajoen Tokyo
1-8-1 Shimo Meguro, Meguro-ku
Tokyo, 153-0064
hotelgajoen-tokyo.com

Makabe: Sakuragawa, Ibaraki Prefecture

In Makabe the entire village participates in the Hina Matsuri festival. Streets are blocked to cars so visitors can stroll through town and see the many colorful displays in homes and stores. The annual Girl's Day celebration includes *nagashi-bina* (floating paper dolls down the river).

visit.ibarakiguide.jp/en/sightseeing/22337/

Inatori: Higashi-Izu, Shizuoka Prefecture

Along a steep path up the hillside, visitors will find 118 ancient stone steps leading to the local shrine that are lined with the most lavish, and longest, outdoor stairstep display of traditional *hina* dolls in the country. Izu is considered the birthplace of the hanging ornaments called *tsurushi kazari*.

inatorionsen.or.jp/

Kyoto: Chimoto Restaurant

▲ This traditional restaurant and gallery space dates back to 1718 and is famous for its fine-dining Kyoto cuisine. It is situated along the scenic Kamo River, and every year, this 300-year-old business hosts an extraordinary display of *hina* dolls created in what is known as palace style: dolls created to resemble the emperor and empress. The dolls are displayed in a historic gallery. An *okami* (business owner/boss), who is the general manager and co-owner of the restaurant, and who is especially knowledgeable, presents a special lecture (available only in Japanese) to guests on the meanings and history of Hina Matsuri celebrations in Kyoto. After the lecture, visitors are served a special Hina Matsuri meal. The exhibition and lecture are available only for those who make reservations for the meal.

Chimoto
140-5, Saitocyo, Shijyodori-sagaru, Shimogyo-ku,
Kyoto, 660-8012
chimoto.jp

Mizusawa: Oshu, Iwate Prefecture

▶ The *hina* dolls in this district are completely different from other regions. Here you'll find *kukuri-bina*, which are flat dolls made with a technique called *oshie* (a padded-cloth picture). There is also another custom unique to Mizusawa: many *kabuki* (theater actors and dancers) and *joruri* (chanting musicians) dolls are displayed on the *hinadan* alongside the emperor, empress, and royal court. The origin of *kukuri-bina* goes back to the Meiji period (1868–1912), when this unusual technique was first introduced. Today, local volunteers have established a preservation society to host the *kukuri-bina* festival. *Photo by Mituo Hosada.*

oshu-kankou.jp

Sakata: Yamagata Prefecture

▲ Sakata once was a major port town, and because of its sea commerce history, its families and museums hold some of the oldest *hina* dolls in the country. These displays sit alongside the *kasafuku* mobiles that dangle from beautiful red umbrella tops. *Photo by Patchwork Tsushin.*

https://visityamagata.jp

Yanagawa: Fukuoka Prefecture

▲ A beautiful river runs through the center of Yanagawa, and every year this town hosts a stunning water parade for Hina Matsuri. The brightly decorated boats are filled with girls and parents dressed in traditional colorful costumes and headdresses.

Mobiles hang above the river, and as the boats and girls pass under them, the spectacle is unforgettable. Along the streets in the town, the *hina* doll displays are flanked with pairs of *sagemon* mobiles. *Photo courtesy of the City Tourist Association, Yanagawa.*

yanagawa-net.com/en/

Naomi Ichikawa is an editor, publisher, curator, and researcher. For twenty years, she served as the editor in chief of Japan's first quilt magazine, *Patchwork Tsushin*. From 2016 to 2020, she served as the editor in chief of *Yomiuri Quilt Time* magazine. In 2020, Naomi launched a new quarterly magazine, *Quilt Diary Japan*, which she published until 2024. The author of four English-language quilt books covering Britain, America, Prince Edward Island, and Canada, she has also authored numerous Japanese-language quilt books. Her editorial work has received several awards, including a certificate of commendation from the American embassy in Japan and a special award from Tourism Canada. Naomi served as the curator of international exhibitions for International Quilt Week Yokohama for two decades, and she has also curated quilt exhibitions all over the world. Naomi provides quilt- and textile-related tours for Japanese quilters traveling to international locales, as well as to foreign quilters visiting Japan.

@qd_quiltdiary

Teresa Duryea Wong is an author, lecturer, and quilt historian. She is the author of six nonfiction books on quilts and textiles, including *Japanese Contemporary Quilts & Quilters: The Story of an American Import*; *Cotton & Indigo from Japan*; and *Sewing & Survival: Native American Quilts from 1880–2022*. She travels to Japan annually to research and study Japanese quilts and interview quiltmakers. Teresa serves as a member of the International Advisory Board of the International Quilt Museum at the University of Nebraska–Lincoln, and is a board member of the Quilt Alliance. She is a contributing writer for *Quiltfolk* magazine and was a regular contributor to *Quilt Diary Japan* (2021–2024). She has presented hundreds of lectures to quilt organizations in the US and Canada, and she is regularly invited to lecture at the annual Quiltcon event hosted by the Modern Quilt Guild. Teresa is also a quiltmaker and antique quilt collector. She holds a master of liberal studies degree from Rice University.

TeresaDuryeaWong.com | @third_floor_quilts

Above: Coauthors Naomi Ichikawa (*left*) and Teresa Duryea Wong (*right*) in Aoyama, a neighborhood in Tokyo. Teresa and Naomi first met in 2014 and kept in touch over the years. The two worked together for several years for the magazine *Quilt Diary Japan*, which Naomi founded and owned. She invited Teresa to serve as a regular contributor. *Photo by Ayako Hachisu.*